IMAGES
of America
LAKE WASHINGTON
THE EAST SIDE

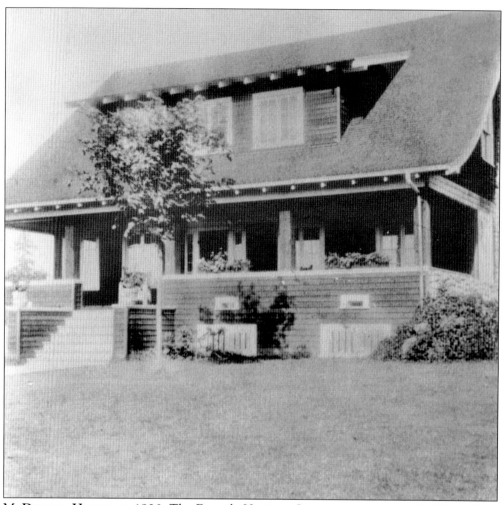

MCDOWELL HOUSE, C. 1920. The Eastside Heritage Center manages over 30,000 artifacts and photographs from the former Bellevue Historical Society and Marymoor Museum. As of this writing, the center has no permanent facility but maintains offices and archival storage in this Craftsman-style house at 11660 Main Street, under a lease from the City of Bellevue. The house was built in 1918 by John H. and Ella McDowell. It has remained remarkably intact over the years. It was originally part of a five-acre parcel that included an orchard with cherry trees, berries, grapes, and other fruit trees.

ON THE COVER: This photograph captures the essence of a day of swimming at Burrows Landing in Lake Washington. Pictured here in 1909 are the following: Albert W., Betty, Don, Chester Kelsey, Watron McDowell, and Leonard Ashwell. Albert S. Burrows homesteaded near the lake in 1882, and more than 120 years later, this landing is still a popular City of Bellevue public park, located at the end of Southeast 15th Street.

IMAGES
of America

LAKE WASHINGTON
THE EAST SIDE

Eastside Heritage Center

Copyright © 2006 by Eastside Heritage Center
ISBN 0-7385-3106-5

Published by Arcadia Publishing
Charleston SC, Chicago IL, Portsmouth NH, San Francisco CA

Printed in the United States of America

Library of Congress Catalog Card Number: 2005937002

For all general information contact Arcadia Publishing at:
Telephone 843-853-2070
Fax 843-853-0044
E-mail sales@arcadiapublishing.com
For customer service and orders:
Toll-Free 1-888-313-2665

Visit us on the Internet at www.arcadiapublishing.com

Contents

Acknowledgments 6

Introduction 7

1. Lake Washington's Natural Setting 9

2. Navigating the Lake 19

3. Lakeshore People and Places 37

4. An Agricultural Legacy 67

5. Lakeside Commerce 93

6. Recreation on and by the Lake 111

ACKNOWLEDGMENTS

Eastside Heritage Center (EHC) volunteers, members, and staff contributed many hours to create this book. Nick Trescases scanned hundreds of negatives and prints. Section photographs were chosen and researched by Teresa Claypool, Diana Schafer Ford, Michael Intlekofer, Michael Luis, and Steve Williams. EHC's executive director, Heather Trescases, directed the image management process and served as general advisor. Volunteer Karen Klett procured photographs and use permission for non-EHC images. Volunteer Nancy Sheets spent hours assisting in photograph selection and research. EHC education coordinators Barbara Williams and Jane Morton, as well as other volunteers, contributed their time and expertise.

The book could not have been completed accurately without the enthusiastic assistance and encyclopedic knowledge of Mary Ellen Piro, who tirelessly tracked down photographs, dates, names, and stories to enrich these pages. Special thanks go to Carolyn Marr of the Museum of History and Industry and Nicolette A. Bromberg, Kristin Kinsey, Nancy Hines, and Wayne Gloege at the University of Washington.

Unless otherwise noted in a caption, all photographs are available from the Eastside Heritage Center. We are indebted to the people and families who have donated their valuable images to the organization's care. Image captions identify specific donor collections and other contributing organizations.

Our Arcadia Publishing editor, Julie Albright, provided invaluable assistance. On a personal note, I would like to thank the Bellevue Regional Library staff, the entire project team, and my family for their moral support and encouragement.

—Teresa Claypool
Project Coordinator

The 2006 Eastside Heritage Center Board of Trustees are Stuart A. Vander Hoek, Iris Tocher, Ross McIvor, Teresa Claypool, Michael Intlekofer, Michael Luis, Libby Walgamott, Margot Blacker, Anne Taylor, Ray Higgins, Lynn Sherk, L. Lee Maxwell, Reagan Dunn, J. P. Perugini, and Tim Johnson.

INTRODUCTION

Hundreds of lakes dot the state of Washington. The largest of these, Lake Washington, lies just east of Seattle, separating the city from the burgeoning suburban area known in the Puget Sound region as the Eastside. On clear days, traffic on the two floating bridges spanning Lake Washington often slows as drivers and passengers drink in the scenic views. Driving east on the bridges, one can see Mount Rainier standing majestically to the south and Mount Baker to the north, framed ahead by the Cascade mountain range and behind by the Olympics. The pristine fresh water sparkles. Evergreen trees and mansions with private docks line the eastern shores. At 22 miles long and nearly three miles wide at its widest point north of Mercer Island, the lake covers 21,500 acres. Its historical impact on the evolution of the eastern shore communities cannot be overstated.

Volunteer historians from the Eastside Heritage Center reviewed hundreds of photographs to create this wonderful book, with the goal of illustrating the lake's historic relationship with Kirkland, Bellevue, Renton, and the towns and neighborhoods of Newcastle, Medina, Hunt's Point, Beaux Arts, Juanita, Houghton, Yarrow Point, Kennydale, Wilburton, and Enatai. Many photographs they found have never been published before and offer glimpses of the lake that even lifelong residents will find novel. Though the Eastside reaches to the Cascade foothills, this book concentrates on the communities that have the lake in common.

To the indigenous Native American tribes, Lake Washington was a resource and a spiritual place. They fished the waters for food and established villages in coves along the lakeshore. Their legends tell of an island that disappears each night and reappears with the dawn. Settlers used the lake as a highway to transport timber, coal, and farm products to market. Some settlers feared the lake's powerful storms and built homes well above the shoreline, away from the water that sometimes appears green, sometimes black, depending upon the weather. Early-20th-century planners, not understanding the impacts of pollution, piped secondary sewage into the conveniently deep waters. By the end of the 20th century, wiser people have devoted resources to cleaning up the lake. Today the lake is appreciated it for its beauty and recreational opportunities.

Several of the Northwest's greatest engineering feats feature Lake Washington. The early settlers wanted to shorten the route from Seattle to Issaquah and the Cascades and from the Eastside to Seattle. The necessarily circuitous route to Puget Sound, through rivers at the lake's south end, frustrated shippers. It was estimated that a load of coal from Newcastle to a ship waiting on the Seattle waterfront was transferred 11 times from wagon to boat and back again. Plans were floated to excavate a canal that would connect the lake more directly to Seattle. Although many routes were proposed, it was not until Hiram Chittenden picked Salmon Bay as the site for permanent locks connecting the waterways to Puget Sound that the plans would come to fruition. He successfully argued that locks could be avoided when connecting the waterway to Lake Washington at the Montlake Cut by merely lowering the lake level.

Work started on the locks in 1911, and in 1916, the Montlake Cut opened, allowing Lake Washington's waters to pour out. The most dramatic effect was at the lake's south end, where it then no longer drained into the Black River. As people watched over a three-month period, the river literally disappeared. People stuffed fish trapped in the remaining pools into gunnysacks. Vast acres of former lake bottom were opened for development by lowering the lake nine feet. With

the new water connection to the city, larger ships could enter the lake, escaping barnacles and corrosive saltwater. More and more boats and ferries traversed the lake, providing transportation for commerce and commuters.

Two other engineering marvels occurred in 1940 and 1963 when two floating bridges allowed direct access by car across the lake from the Seattle to the Eastside. Both bridges are composed of innovative floating sections that rest atop pontoons attached by cable to the lake floor several hundred feet below.

Today people swim in the lake. They boat on it, they walk and run beside it, they drink it. They water their lawns with it. They admire the western views of Seattle and beyond, offered by one of the area's most influential geographical features. Though Lake Washington undoubtedly posed navigational and commercial challenges to the pioneer spirit of development, the images in this book reveal a benevolent, even reverent attitude toward Lake Washington. It was not regarded as a monster to be tamed; rather it was clearly a resource to be maximized. The time it took to accomplish this goal actually benefited the eastern communities by protecting them from early overdevelopment and industrial pollution. By being difficult to access, the lake allowed the communities to move slowly through the extraction industries to farming and from farming into suburbia. Today the lakeside communities on the Eastside cherish their unique characteristics, but the unmistakable common denominator, past, present, and future, is Lake Washington.

—Sherry Grindeland
The Seattle Times, Eastside Edition

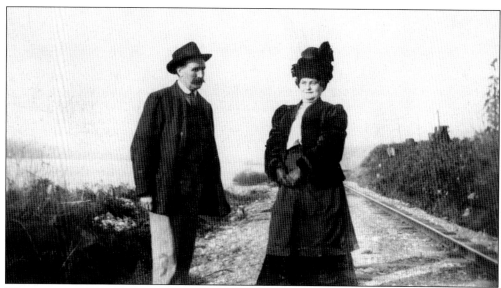

WILLIAM AND AGNES MITCHELL, C. 1900. The Mitchells wait for the train in Kennydale. Their daughter Margaret married George Lathrop Colman, son of James Manning Colman. In 1886, James and a young man named William Patten were shot while rowing to Seattle to appear in court over a dispute with George Miller, who owned land in the area of what is now Beaux Arts. In 2005, the Fawcett family donated to Eastside Heritage Center the diaries of James Manning Colman's wife, Clarissa, who wrote in detail about the trial and her daily life from 1886 to 1916. (Colman collection.)

One
Lake Washington's Natural Setting

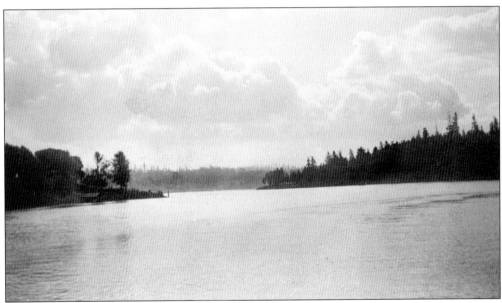

Pristine Lake Washington East Channel, c. 1915. This view of Mercer Island on the left and Beaux Arts on the right shows the tranquil setting before the earliest East Channel Bridge was built in 1923. In these days, Native Americans and early pioneers plied the lake's quiet waters. For centuries, the eastern lakeshore was nearly impenetrable, with thick old-growth forest growing to the water's edge. Formerly landlocked, area settlers changed the lake forever, first by opening it to Puget Sound by constructing the Lake Washington Ship Canal and then by nearly destroying it with wastewater from their fast-growing communities. But the lake has more than survived, and local communities recognize and appreciate the lake's starring role in the area's quality of life, an environmental treasure worth preserving. (Courtesy Beaux Arts Historical Association.)

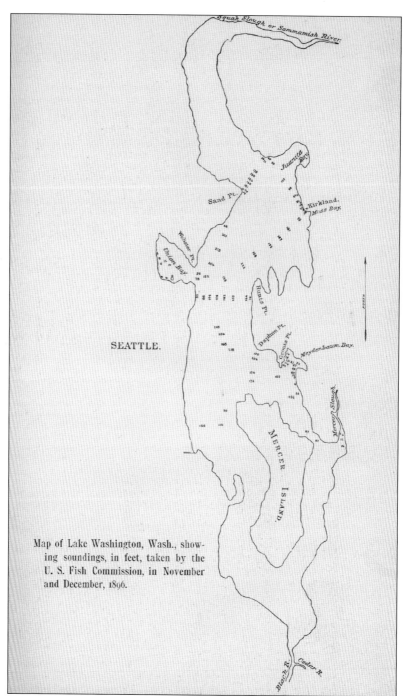

Map of Lake Washington, Wash., showing soundings, in feet, taken by the U. S. Fish Commission, in November and December, 1896.

Map of Lake Washington, 1896. This map shows soundings, in feet, and was taken by the U.S. Fish Commission to determine fish populations. From the north, note the location of Squak Slough into the Sammamish River. Bellevue grew up south of Hunt's Point, around Meydenbauer Bay (misspelled on the map) and south to Mercer Slough. At the lake's south end is the now-eliminated confluence of the Cedar and Black Rivers. (Courtesy University of Washington Freshwater and Marine Image Bank.)

CONFLUENCE OF CEDAR AND BLACK RIVERS, C. 1899. This image shows the dam used to change the rivers' courses. (Courtesy University of Washington [UW].)

BLACK RIVER, C. 1905. The Black River flowed from Lake Washington's south end to the White River southwest of Renton. The river flowed either into or out of the lake, fluctuating due to storm runoff. By late fall 1916, the river had disappeared, drained completely by the permanent lowering of Lake Washington to create the Seattle (Lake Washington) Ship Canal. The fish source for the Duwamish tribe was eradicated, and they left the area. (Courtesy UW.)

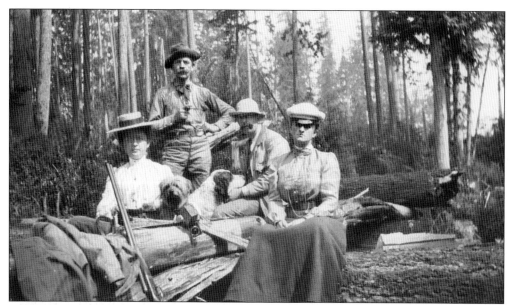

CRUSES HUNTING, 1921. Pictured, from left to right, are Mary Cruse, William Cruse, and unidentified friends. Though this photograph is at Cottage Lake, thousands of waterfowl stopped at Lake Washington marshes during their spring and fall migrations. Native American hunters trapped the birds with handwoven nets strung between tall poles. A state law, passed in 1909, made it illegal to hunt within one mile of the Lake Washington shoreline. (Phyllis Hill Fenwick collection.)

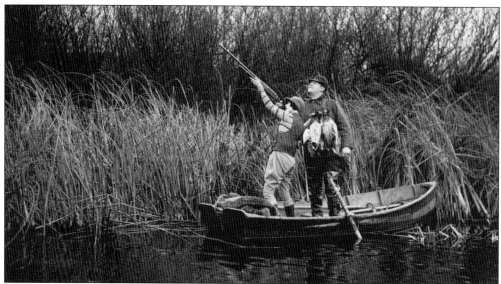

DUCK HUNTING, 1930s. Over 200 species of wild birds are found in the Lake Washington area. Some of them are mallard, gadwall, widgeon, teal, bufflehead, goldeneye, scaup, shoveler, pintail, canvasback, wood duck, ruddy duck, bittern, rail, merganser, grebes, loons, heron, cormorant, coot, gulls, geese, swans, osprey, bald eagle, kingfisher, marsh hawk, red-tailed hawk, sharpshinned hawk, great horned owl, screech owl, barn owl, Rufous and Anna's hummingbirds, pileated, downy and hairy woodpeckers, Stellar's jay, Marsh and Bewick's wrens, red-winged blackbird, and sandpiper. (Courtesy Museum of History and Industry [MOHAI].)

CHARLES EMINSON, C. 1924. Charles, an uncle of Diana Schafer Ford, proudly displays his modest catch. The lake is home to many different fish, but perhaps the most prized is the "king," or Chinook salmon. Other species are Coho, Sockeye, and Kokanee salmon; cutthroat, steelhead, rainbow, and Dolly Varden trout; smelt, peamouth, squawfish, dace, shiner, sucker, stickleback, sculpin, carp, tench, bass, bullhead, crappie, and perch. (Diana Schafer Ford collection.)

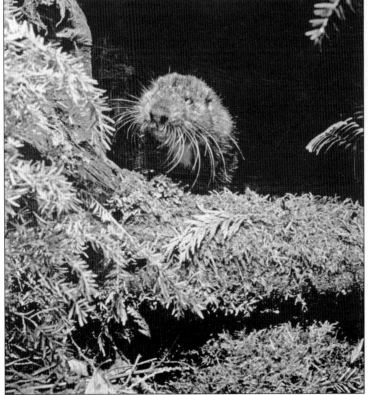

MOUNTAIN BEAVER. Fur trappers entering the northwest found Chinook Indians wearing robes made from the skins of this animal. Excited reports of anticipated riches from the mountain beaver were relayed to expedition sponsors; however, this animal is not a beaver and does not live in the mountains. It is its own species, *aplodontia rufa,* and is found nowhere in the world but the hills and lowlands of the Pacific Coast. (Victor Scheffer collection.)

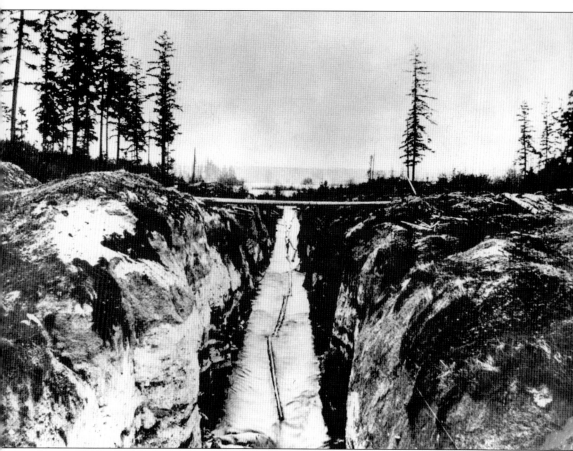

LOG SLUICE TO LAKE UNION, C. 1886. In 1885, the first water connection between Lake Washington and Portage Bay was completed by Chinese laborers contracted by Wa Chong. This simple ditch, with a gate at the upper end, allowed Lake Washington access to a new mill on Lake Union, beginning water commerce that had been dreamed of for 30 years.

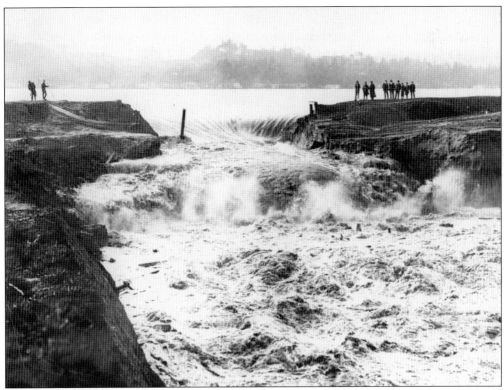

OPENING THE MONTLAKE CUT, AUGUST 25, 1916. Over the course of three months, Lake Washington water was slowly released into the cut past gates at the other end, lowering the big lake by nine feet to create the ship canal. The lake's shoreline was forever changed; over 1,000 acres of wetland and marsh dried up, fish died, and waterfowl left. The Black River dried up and the Cedar River salmon run was destroyed.

SHIP CANAL OFFICIAL OPENING, JULY 4, 1917. The *Roosevelt*, flagship of Admiral Peary's North Pole expedition, leads a parade of 200 boats into the Montlake Cut for the Lake Washington Ship Canal's grand opening. Ships were able to use the canal since May 8, 1917. Thomas Mercer's suggested names, Washington and Union, forecasted the "union between Lake Washington and the Sound." (Courtesy *The Seattle Times*.)

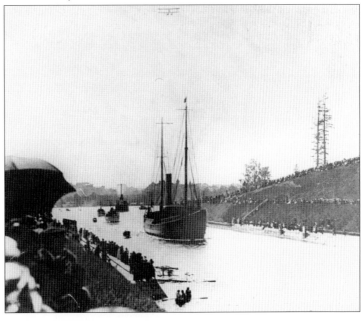

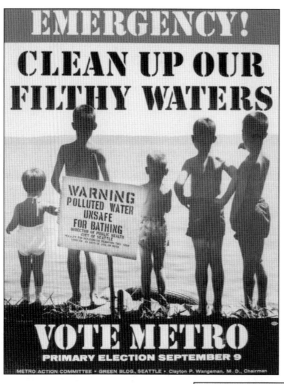

POLLUTED WATER, 1958. In the early 1900s, the lake was considered big enough to handle raw sewage. In 1922, Seattle had 33 separate outfalls into the lake. By 1941, 10 Eastside plants were dumping treated sewage into the lake, up to 20 million gallons per day by 1955. By 1958, the lake's shoreline was dotted with these warning signs stating, "Polluted water—unsafe for bathing." (Courtesy King County.)

METRO TRUNKLINE, 1961. Once Metro was established as a collaborative entity, cleanup began with a sewer trunkline along the Eastside. Some precast concrete pipe sections were big enough to hold a truck. Treatment plants were constructed at West Point in Seattle and near the Black River in Renton, receiving all sewage by 1968. Shortly after the first treated discharge went into Puget Sound in February 1963, the lake waters showed rapid improvement. (Courtesy King County.)

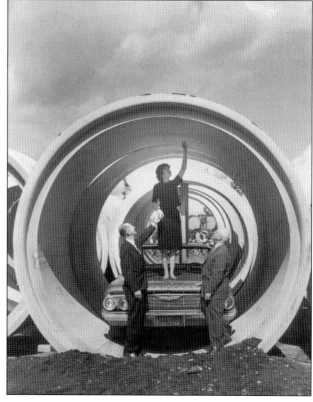

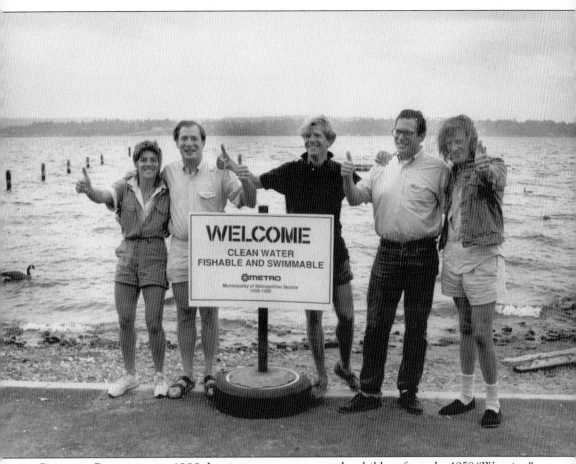

CLEANUP CELEBRATION, 1988. In a joyous reenactment, the children from the 1958 "Warning" photograph return to celebrate clean water and beaches after 30 years of cooperative effort. University of Washington's Dr. W. T. Edmundson provided scientific data and attorney James W. Ellis led the campaign to form a joint governmental body and procure funding, resulting in the Municipality of Metropolitan Seattle (Metro). Today the lake's cleanup story is world renowned. (Courtesy King County.)

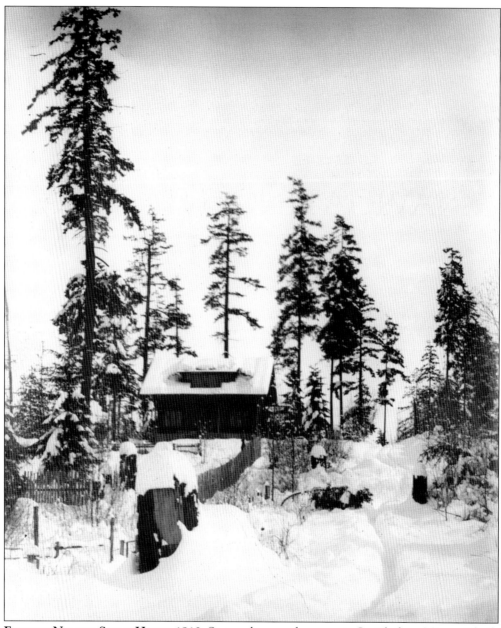

EDWARD NELSON SEARS HOME, 1910. Sears, a lawyer who came to Seattle from Missouri, built this house in Bellevue in 1910. The area occasionally experienced heavy snowstorms, such as the "Big Snow" of January 1880, when 64 inches of snow fell over eight days. Today the area rarely experiences more than a day or two of snow. The original house is what is known as a Wilson Bungalow, a standard house plan in 1910. (John Sears collection.)

Two
NAVIGATING THE LAKE

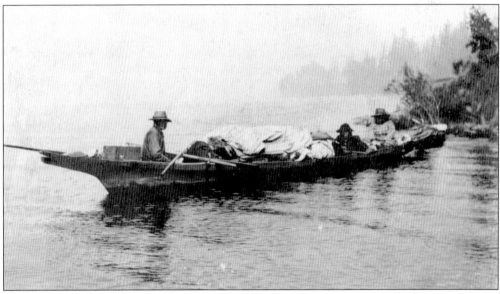

NATIVE AMERICAN CANOE, C. 1900. John Chudups, left, known as "Chodups" and "Lake Union John," sits with two unidentified Native Americans in a canoe on Lake Union. He was from the Duwamish people and lived on Portage Bay. This is a Coast Salish canoe design, with a mast sticking out beyond the vessel's notched prow. These canoes, and later scows, ferries, and steamers, were crucial to allow Seattle residents access across the lake. Soon bridges changed everything. The lake's depth ruled out pilings, but an engineer named Homer Hadley originated the idea of a concrete pontoon bridge. By the mid-1930s, money became available and construction began. The first floating bridge (now bearing Interstate 90) opened in 1940, along with a rebuilt concrete bridge across the East Channel and a viaduct spanning Mercer Slough. More than any other factor, the bridges changed lake boating from necessary transportation to pleasure boating. (Courtesy MOHAI.)

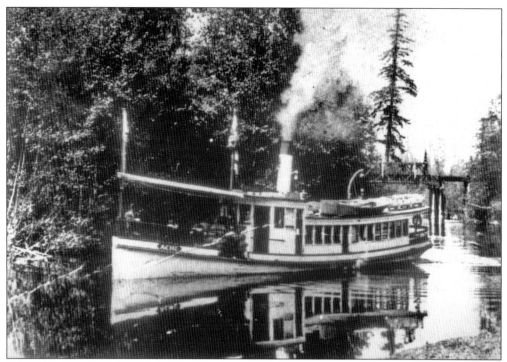

STEAMER ACME, C. 1888. The *Acme*, like many of the early steamers, was built on Lake Washington.

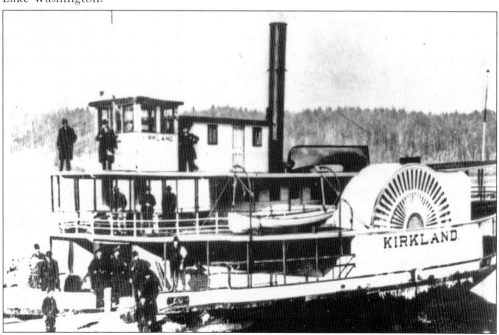

SIDEWHEELER KIRKLAND. In 1889, the *Kirkland* began service on Lake Washington. It was owned by Leigh S. V. Hunt of the Madison Street Cable Company. In 1891, Pres. Benjamin Harrison was carried around Lake Washington on the *Kirkland*, while he reviewed the proposal for the ship canal.

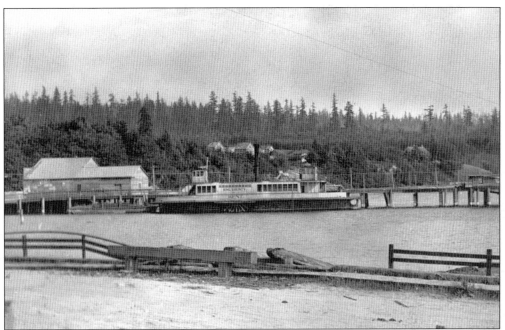

FERRY KENT, C. 1900. This ferry's name is the *King County of Kent*, the first one owned by the county and the first boat on the route from Madison Street to Kirkland. The county tried, but failed to compete with the privately run fleet operated by John Anderson, owner of Anderson Shipyard, also called Lake Washington Shipyard, now Carillon Point.

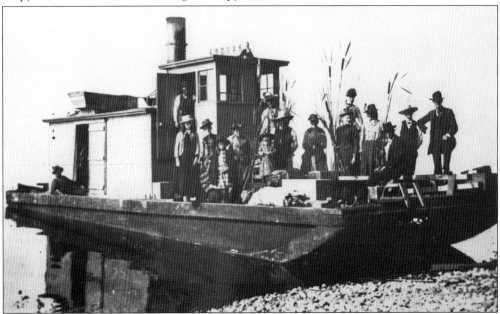

THE SQUAK, C. 1905. Built in 1881, the *Squak* was a cargo and work boat that served the shores of Lake Washington, the Sammamish River, and Lake Sammamish. During the early days of settlement, most areas along the lakeshore did not have either roads or docks, so a scow like the *Squak* was needed to bring cargo to shore. The girls in this photograph are possibly Peter Kirk's daughters.

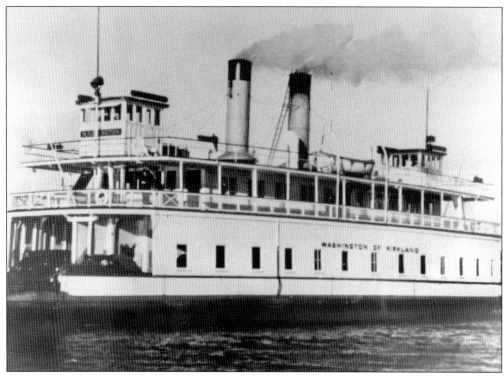

FERRY WASHINGTON. The *Washington* was 160 feet long and was built on Lake Washington in 1908. In 1910, it helped save the Kirkland shingle mill from destruction by fire.

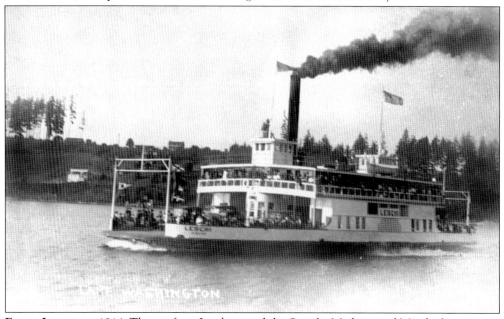

FERRY LESCHI, C. 1914. The car ferry *Leschi* served the Seattle, Medina, and Meydenbauer route from December 27, 1913, to August 31, 1950. The *Leschi* stopped calling regularly at Meydenbauer Bay in 1921 but continued on the Medina route. It was the first ferry in Washington designed for motor vehicles.

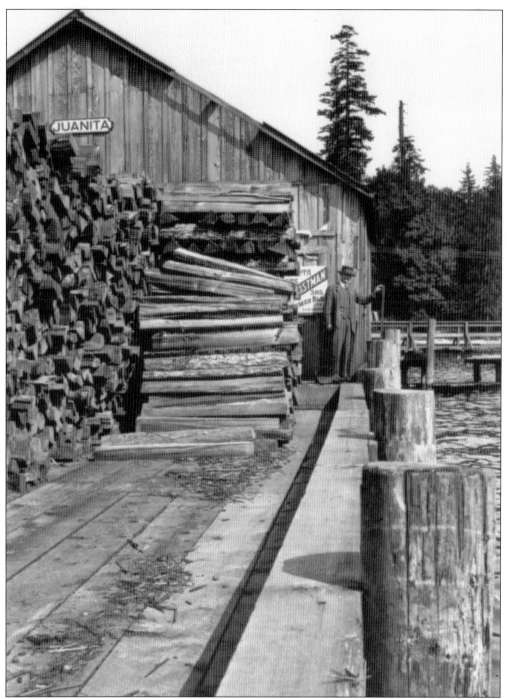

JUANITA FERRY DOCK, EARLY 1900S. Ferries were serving Juanita and Kirkland by the 1880s. At this point, the steamers were fired by wood, such as this huge woodpile on the Juanita dock. Although wood was plentiful, coal was a more efficient fuel, and after the discovery of coal at Newcastle, future steamers used coal in their boilers. (Courtesy King County Public Works.)

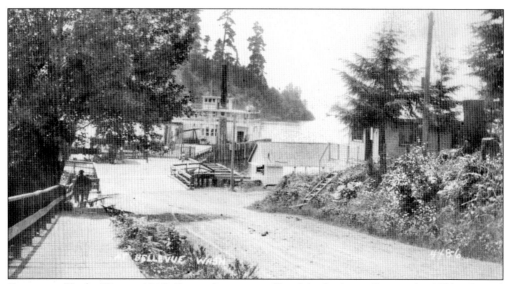

BELLEVUE FERRY DOCK, 1915. Ferries began to call in Meydenbauer Bay in the 1890s. A road led up the hill to Main Street. This photograph of the Bellevue dock was taken in 1915, just before the lake was lowered. The boardwalk in the left of the photograph went from the waterfront dock to Wilburton Hill. The street leading to the ferry is an extension of today's 100th Avenue Northeast.

Save Time - Distance - Money

LAKE WASHINGTON FERRIES

FOOT PASSENGERS

Single Trip 15c; Round Trip 25c; 12 Trip Commutation Ticket 8⅓c Trip. Total $1.00. Commutation Tickets originally for commuters making two trips daily are now sold to anyone, with no time limit.

RATES FOR AUTOMOBILES UNDER 3000 POUNDS

Including driver 50c; Round Trip 75c; 5 Trip Commutation at 25c trip including driver. Total $1.25.

RATES FOR AUTOMOBILES OVER 3000 POUNDS

Including driver 60c; Round Trip 90c; 5 Trip Commutation Ticket at 30c trip, including driver. Total $1.50.

TRUCKS, COMMERCIAL CARS, FREIGHT VEHICLES

½ Ton	¾ Ton	1 Ton	1½ Ton	2 Ton	2½ Ton	3 Ton	5 Ton
Same as Light Auto		Single Trip Including Driver					
	.80	1.00	1.10	1.20	1.30	1.40	1.60
		Ten Single Trips Including Driver					
	4.00	5.00	5.50	6.00	6.50	7.00	8.00

FERRY TIMETABLE, 1930. From the earliest days of settlement on Lake Washington's eastern side, regular ferry service was provided from Seattle. Ferries to Medina, Meydenbauer Bay, and Mercer Island left from Leschi, and the ferry to Kirkland left from Madison Street. Frequent service and a short, inexpensive crossing made commuting from the Eastside a practical alternative to living in Seattle.

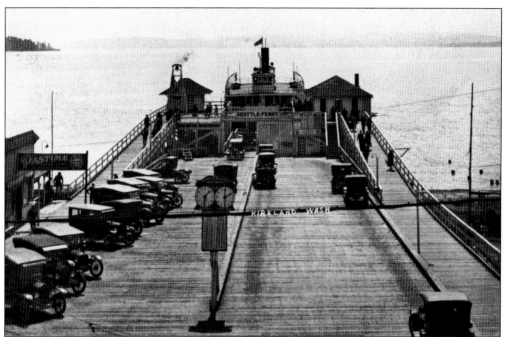

FERRY LINCOLN, 1920. Until the floating bridge changed the geography in 1940, Kirkland was the most developed city on the lake's east side. This elaborate ferry dock served downtown Kirkland from Madison Street in Seattle. The ferry *Lincoln*, seen here at the dock, served Kirkland from 1915 to 1940, when the new bridge put car ferries out of business. Passenger ferries continued to serve Kirkland and Medina until the 1950s.

CROSS LAKE WASHINGTON ON THE FERRIES

SHORT ROUTE TO and FROM SEATTLE and EASTWARD
CAPACITY FIFTY AUTOMOBILES EACH
SCHEDULE EFFECTIVE DECEMBER 11, 1930

Seattle-Kirkland Route		Medina Route		Mercer Island Route	
LEAVE SEATTLE (Madison Park)	LEAVE KIRKLAND	LEAVE SEATTLE (Leschi Park)	LEAVE MEDINA	LEAVE SEATTLE (Leschi Park)	LEAVE ROANOKE
*6:15 A.M.	*5:45 A.M.	*5:40 A.M.	*6:00 A.M.	*6:25 A.M.	*6:40 A.M.
7:15 A.M.	6:45 A.M.	6:30 A.M.	6:50 A.M.	6:55 A.M.	†7:15 A.M.
8:30 A.M.	7:45 A.M.	†7:05 A.M.	†7:25 A.M.	7:30 A.M.	*7:50 A.M.
9:45 A.M.	9:10 A.M.	7:40 A.M.	8:00 A.M.	8:05 A.M.	8:25 A.M.
10:55 A.M.	10:20 A.M.	8:20 A.M.	8:40 A.M.	9:00 A.M.	9:15 A.M.
12:00 Noon	11:30 A.M.	9:00 A.M.	9:15 A.M.	10:30 A.M.	10:45 A.M.
1:30 P.M.	1:00 P.M.	10:00 A.M.	10:15 A.M.	1:30 P.M.	1:45 P.M.
2:30 P.M.	2:00 P.M.	11:00 A.M.	11:15 A.M.	3:45 P.M.	4:00 P.M.
4:00 P.M.	3:00 P.M.	12:00 Noon	12:30 P.M.	5:00 P.M.	5:15 P.M.
5:15 P.M.	4:45 P.M.	1:00 P.M.	1:15 P.M.	*5:35 P.M.	*5:50 P.M.
6:05 P.M.	5:40 P.M.	2:00 P.M.	2:15 P.M.	6:10 P.M.	6:25 P.M.
7:00 P.M.	6:30 P.M.	3:00 P.M.	3:15 P.M.	6:45 P.M.	7:00 P.M.
8:00 P.M.	7:30 P.M.	4:00 P.M.	4:15 P.M.	8:30 P.M.	†8:40 P.M.
9:00 P.M.	8:30 P.M.	5:00 P.M.	5:15 P.M.	10:40 P.M.	10:55 P.M.
10:30 P.M.	9:30 P.M.	5:35 P.M.	5:50 P.M.	12:00 P.M.	†12:10 A.M.
12:00 P.M.	11:30 P.M.	*6:10 P.M.	*6:25 P.M.		
		6:45 P.M.	7:10 P.M.	*Omitted Sundays and Holidays	
*Omitted Sundays and Holidays		7:30 P.M.	8:00 P.M.	10 Minutes Crossing to Roanoke, Mercer Island	
Only 20 Minutes Crossing the Lake to Kirkland		10:30 P.M.	9:00 P.M.		
		10:00 P.M.	10:20 P.M.	**AUTOMOBILE RATES**	
		11:15 P.M.	11:35 P.M.	Light Car—2600 lbs. and under:	
		†12:00 P.M.	12:25 A.M.	One Way	.50
		†(via Roanoke)		Round Trip	.75
J. L. ANDERSON, Operator		*Omitted Sundays and Holidays		Heavy Car—Over 2600 lbs.:	
Leschi Park, Seattle, Wash.		Overlake Golf Club Special Trip Saturdays Only		One Way	.60
		Lv. Seattle 12:30 P.M.		Round Trip	.90
For Information Phone East 5100		Lv. Medina 12:45 P.M.		Commutation Rates Half of One-Way Fare All Rates Include Driver	

FERRY FARE CARD, 1930. This card provides an eastward view of the ferry routes from Seattle across the lake. Lake Sammamish lies parallel to Lake Washington, with Mount Rainier to the south.

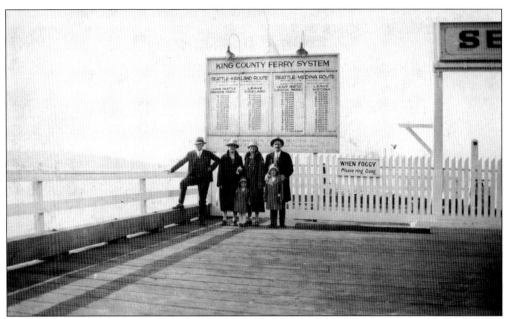

PEOPLE ON MEDINA FERRY DOCK, C. 1925. The primary car-ferry route serving the central section of Lake Washington's east shore stopped at Medina. The site pictured here now houses Medina City Hall. The schedule lists times for the Seattle–Kirkland route and the Seattle–Medina route. The sign to the unidentified group's right states, "When foggy please ring gong."

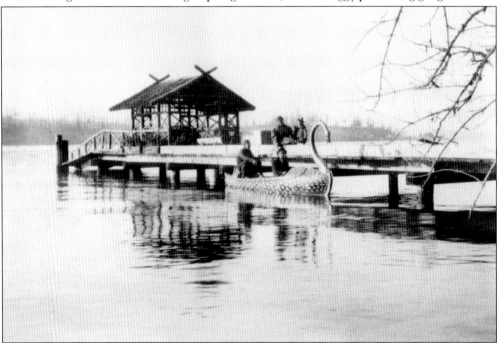

BEAUX ARTS FERRY DOCK. The founders of Beaux Arts embraced the Arts and Crafts movement, and this is reflected not only in the elaborate design of the waiting shed at the Beaux Arts ferry dock, but also in the swan boat that was frequently moored there. (Courtesy Beaux Arts Historical Association.)

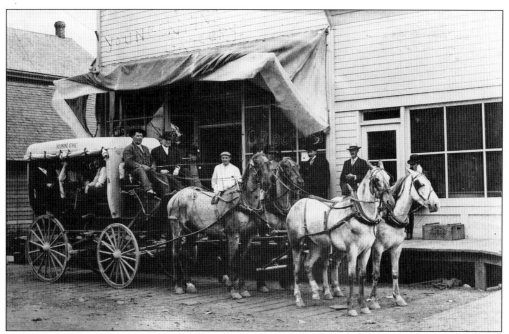

PARKS STAGECOACH, REDMOND, 1904. Crossing Lake Washington by ferry was easy compared to traveling the primitive roads with early vehicles on the other side. It was a challenge to get far beyond the shoreline. This 1904 photograph shows the stage line that took passengers and cargo from the ferry dock at Kirkland over Rose Hill to Redmond.

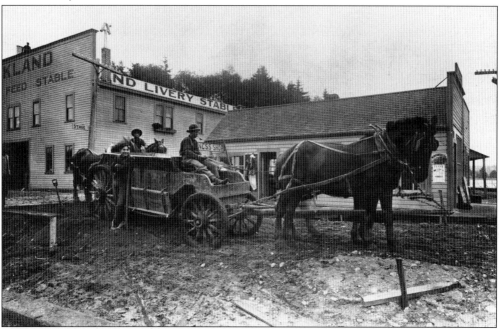

LAYING PLANKS ON KIRKLAND AVENUE, C. 1910. In 1910, even Kirkland, the most advanced Eastside city, was trying to get beyond mud roads. The crew in this photograph lays a plank road on Kirkland Avenue near its main intersection with Lake Street. In the background are the livery stable and harness shop.

27

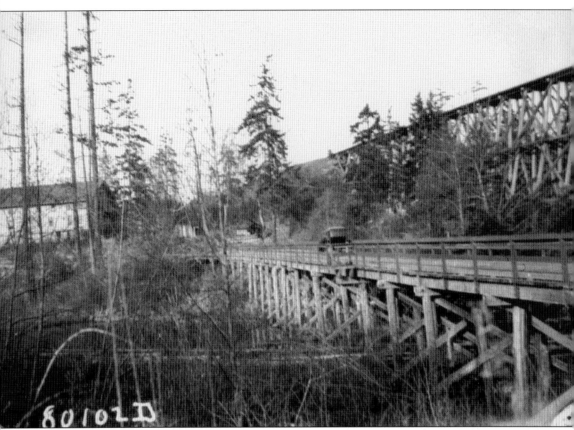

WILBURTON TRESTLES, 1920s. The route from Newport to Bellevue passed directly across the marshes of the Mercer Slough. The railroad trestle, built in 1891, crossed the slough at Wilburton, while the Newport-Bellevue Road had its own trestle below. The trestle is still in use, and the road, although now paved, still exists as part of Lake Washington Boulevard. The rail trestle was 984 feet long and 102 feet high.

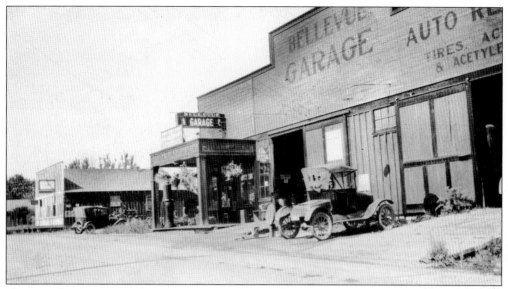

HANSON GARAGE, 1925. In 1919, George and Arvid Hanson opened their garage on Main Street in Bellevue and soon added a car dealership. It was just the second automotive service business in the area, the first of which opened just the year before in Medina. This picture was taken in 1925, looking west on Main Street.

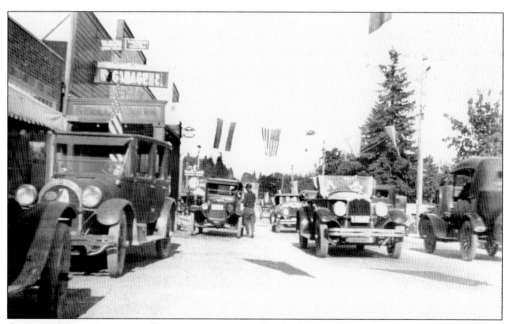

CARS ON MAIN STREET IN BELLEVUE, C. 1930. By the late 1920s, Bellevue's Main Street was a busy thoroughfare. This photograph shows cars passing under street decorations for the Strawberry Festival around 1930. The Hanson Garage is on the left. The street is still called Main Street, and it anchors the east-west street numbers on the Eastside.

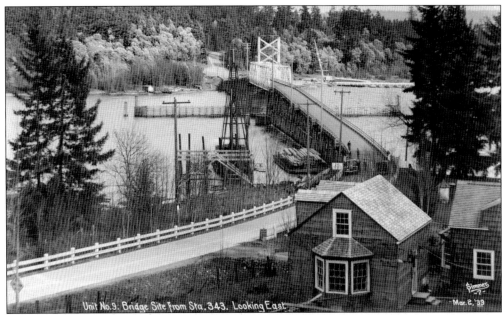

EAST CHANNEL TRUSS BRIDGE, LOOKING EAST, 1937. Mercer Island's earliest connection to Lake Washington's east shore was this truss bridge, constructed in 1923 and replaced in 1940. The photograph is taken from Mercer Island, looking across the East Channel at Enatai, with construction of the new bridge just getting started on the Mercer Island shore. (Courtesy Washington State Department of Transportation [WSDOT].)

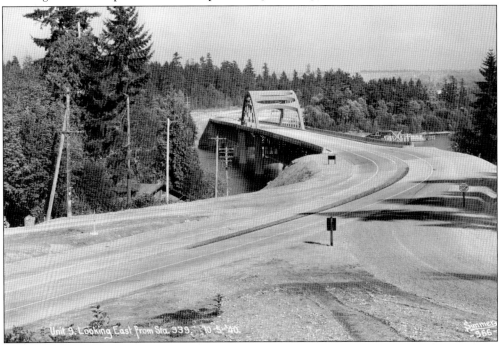

EAST CHANNEL BRIDGE, 1940. A concrete and steel span replaced the wood truss across the East Channel in 1940. This bridge was replaced in 1981 by a pair of structures with a total of eight lanes. (Courtesy WSDOT.)

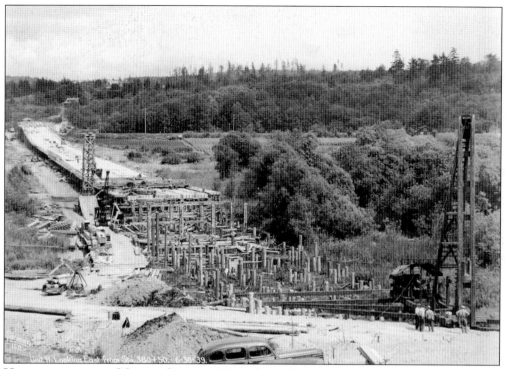

HIGHWAY THROUGH MERCER SLOUGH, 1938. Once the new highway from Seattle hit Enatai, it ran into the Mercer Slough, which was not stable enough to support a road. The solution was to elevate a section of roadway over the slough, resting it on pilings driven into the muck below. The greatly expanded Interstate 90 now crosses this same spot. (Courtesy WSDOT.)

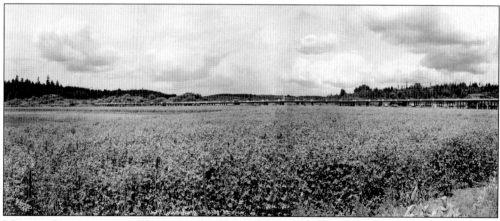

MERCER SLOUGH, 1939. This panorama shows Mercer Slough, looking north, with the newly completed viaduct in the distance. The south part of the slough was still actively farmed at that time. The plants shown may be peas or beans. (Courtesy WSDOT.)

31

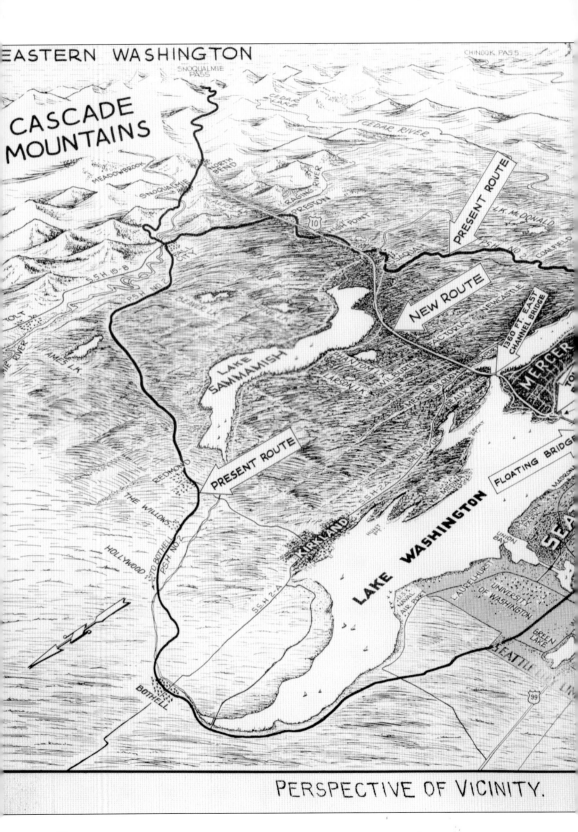

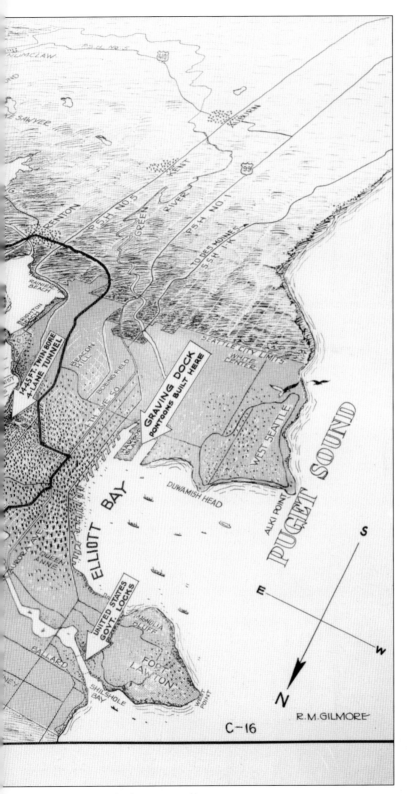

PROPOSED BRIDGE VICINITY, 1935. This illustration shows the proposed route of the new bridges across Mercer Island to be completed in 1940. The bridge's selling point was clearly the shortening of the route from Seattle across the Cascade Mountains, but its real impact would be to open up Lake Washington's east side to booming development. To the west, on Harbor Island, are the graving docks where the floating pontoon sections would be built. (Courtesy WSDOT.)

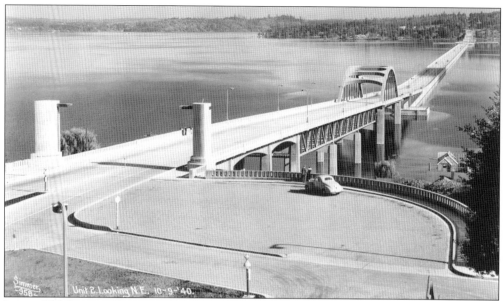

LACEY V. MURROW FLOATING BRIDGE, 1940. The new floating bridge, popularly known as the Lake Washington Floating Bridge, opened in 1940 and was an engineering marvel. At 200 feet deep, Lake Washington could not be bridged with pilings, and the shores lacked good anchoring for a suspension bridge. This bridge sank during a storm on November 25, 1990, during construction of the present-day bridge. This photograph looks east, with Mercer Island on the right and Bellevue in the distance on the left. (Courtesy WSDOT.)

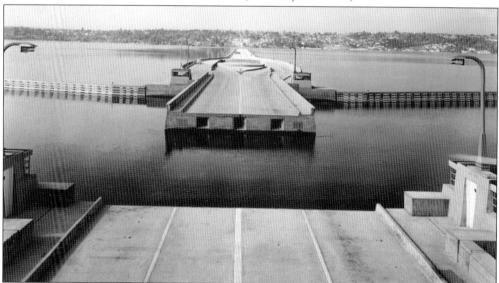

FLOATING BRIDGE DRAW SPAN, 1940. This view looks west toward Seattle's Mount Baker district. The new floating bridge required a draw span because the bridge approaches and the East Channel Bridge were too low for ships to pass under. To open it, a section of the bridge was floated into a space between the lanes. This elaborate structure created the infamous "bulge," seen near the top of the photograph. Maneuvering around the bulge was often a terrifying moment for Eastside drivers, especially when traveling in the reversible lane. It was removed in 1981. (Courtesy WSDOT.)

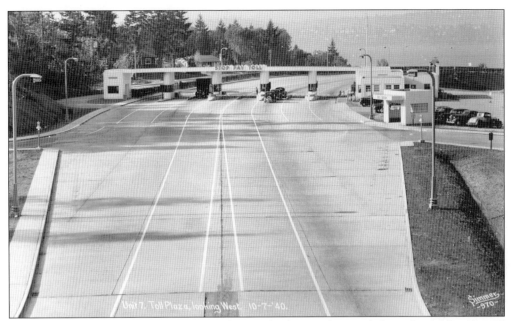

FLOATING BRIDGE TOLL PLAZA, 1940. The new bridge was financed through state bonds paid by tolls collected from all cars crossing the bridge. Twelve thousand vehicles crossed on opening day, more than twice the expected number. By the late 1940s, the average number of cars per day was 5,266, far exceeding the original estimate of 2,800. In 1989, close to 70,000 passed over the bridge in a day. This photograph looks west to Seattle. (Courtesy WSDOT.)

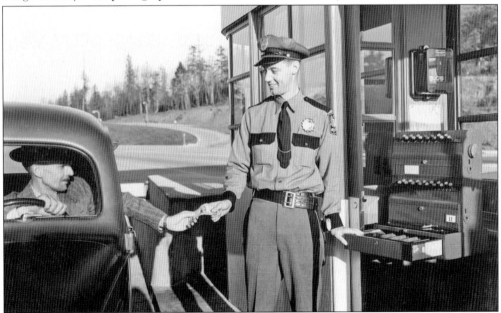

TOLL COLLECTOR ON FLOATING BRIDGE, 1940. A toll collector accepts a fare from a satisfied customer. The toll was 25¢ for car and driver, plus 5¢ for each passenger. The first to cross without paying was a prankster who lay motionless on a stretcher while his pals claimed he was a corpse and should not be charged the nickel toll. Bonds were paid off and the tolls were discontinued in 1949. (Courtesy WSDOT.)

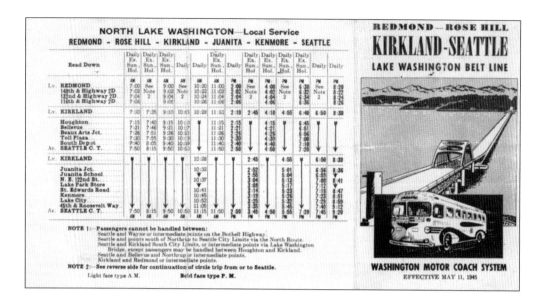

Bus Schedule for the Kirkland-Seattle Lake Washington Belt Line, 1945. The new floating bridge, combined with an expanding road network, made possible a circular bus route that took passengers between Seattle and the Eastside, either north through Juanita, Kenmore, and Lake City or south across Mercer Island. The travel times from Bellevue to downtown Seattle shown on this timetable are exactly the same for buses on that route today. (Mildred Larsen collection.)

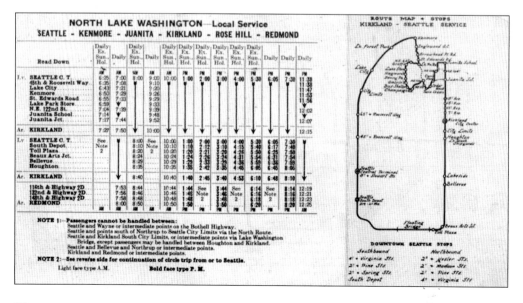

Three
LAKESHORE PEOPLE AND PLACES

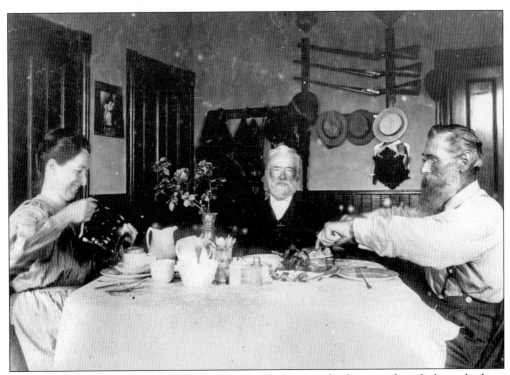

LAKESIDE FAMILY, LATE 1800S. In this wonderful photograph, three unidentified people share tea in a rare interior view found among Lucile McDonald's Eastside notes. Lucile's columns and books chronicle Eastside history and especially describe everyday life. Life was not easy for the early pioneers in the dense forests near the lake. They looked forward to visits and were hospitable to traveling strangers. (Richard McDonald collection.)

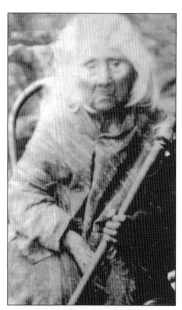

MARIE LOUIE, 1917. Marie Louie was a familiar face along the Lake Washington shoreline and was known as Gotshoblo by her people, the Snoqualmie Indians. Born in 1798, this photograph was taken the year before she passed away at age 120. She traveled by foot, horse, and canoe along the rivers, lakes, and mountains gathering food and medicinal and basket materials. Mary Louie touched many people during her long life. She was a teacher, healer, traveler, and artisan, and many of her descendents live in the Seattle and Eastside area.

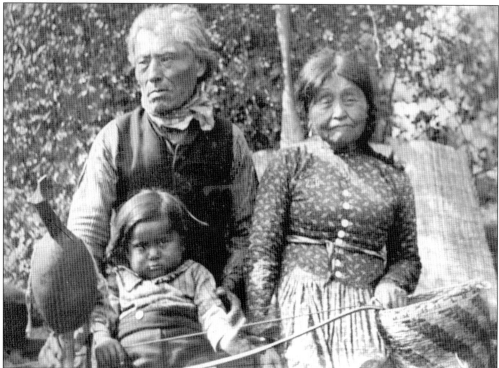

ZICKCHUSE FAMILY, C. 1890. The Zickchuses of the Snoqualmie tribe posed with their son Lolota, meaning Little Old Man. Their small son, dressed in shirt and pants, sits on a fur rug, holding a bow in his lap. His mother is standing by the woven mats and holds a basket. In 1855, the Snoqualmies ceded all their land to the federal government. Their tribe was one of the Puget Sound region's largest tribes, residing in 96 longhouses, with a population of 3,000 to 4,000 in 14 permanent winter villages. (Photograph by Abby Denny Lindsley; courtesy MOHAI.)

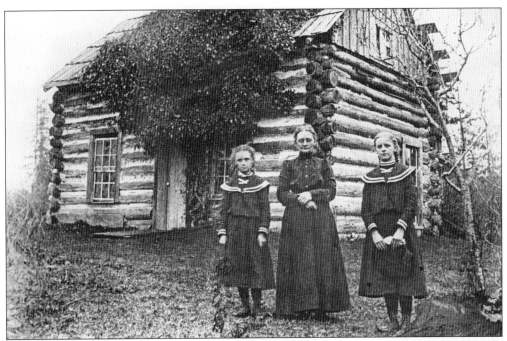

BECHTEL FAMILY, 1899. Isabel Bechtel and daughters Maude and Jessie pose in front of the family cabin in Lochleven. Isabel's husband, Isaac Bechtel Sr., became the first Bellevue postmaster. An 1880 map of King County shows only three communities on the Eastside—Juanita, Houghton, and Newcastle. The territorial census of 1887 listed Bellevue residents as living in Newcastle. After Isaac's death in 1890, his wife, Isabel, carried on as postmistress for the following year.

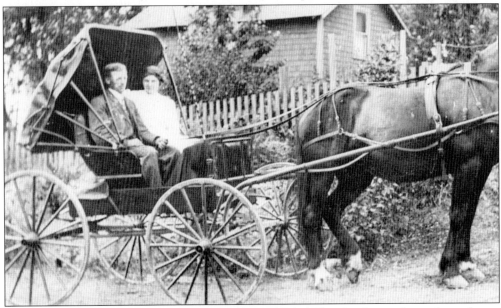

YOUNG LOVE, JULY 12, 1924. Isaac Bechtel Jr. and Ethel Shiach ride in a horse-drawn buggy in Kirkland. They met when 16-year-old Isaac picked up Ethel for her parents, William and Kate Shiach. They fell in love and married in 1917. The Shiachs adopted Ethel when she was five years old, and she was their only child. The Bechtel children were the heirs of the Shiach property.

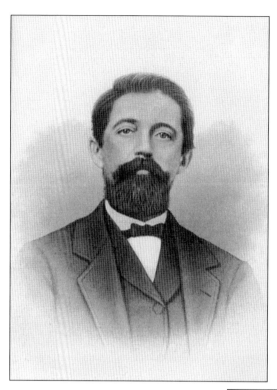

JAMES MANNING COLMAN, C. 1876. Colman, a descendent of the *Mayflower* pilgrims, came to the Washington Territory in 1875. He was an active citizen, serving two terms as county commissioner. On February 8, 1886, he and a young man, William Patten, were shot dead while rowing in a small boat on Lake Washington. Their bodies were found near the south tip of Mercer Island. Three trials were held, and the defendant, a man named Miller, was convicted at the third one. After two years, a fourth trial exonerated Miller, and he was set free. Eastside Heritage Center has the original diaries of his wife, Clarissa. (Courtesy Seattle Public Library.)

AARON MERCER, 1863. Aaron Mercer and his wife, Ann, filed a claim in 1863 on an inlet of Lake Washington's eastern shore where they had lived since 1861. It became known as Mercer Slough. Aaron and his famous brothers Asa and Thomas (Seattle pioneers) migrated in 1852 to Oregon by wagon train from Illinois and eventually made their separate ways to Seattle. Aaron had served as a doctor on the wagon train and worked in this capacity for mining operations in Oregon. By the time he and Ann homesteaded on the west side of Mercer Slough, they had four children; seven more children were born, and the youngest drowned there. In 1872, while coal mining was booming, Mercer sold his property and moved to the Duwamish Valley, where the children could attend school. The Mercers are considered Bellevue's first citizens.

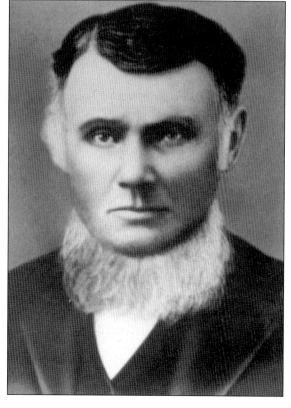

WILLIAM MEYDENBAUER, C. 1870. Early homesteader William Meydenbauer, a German-born baker, rowed across Lake Washington from Seattle in 1869 and staked out his 80-acre claim in a picturesque cove that became known as Meydenbauer Bay. Although his main residence and business were in Seattle, he built a small cabin on his land near the Lake Washington shore.

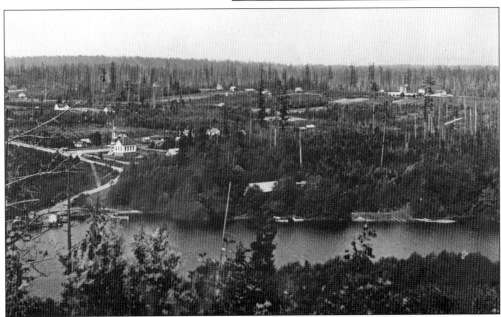

MEYDENBAUER BAY, 1902. Early Bellevue is pictured from across Meydenbauer Bay in this photograph, taken in the Moorland area. Up the hill from the boat landing of the Seattle-bound ferry (1892–1920) was the school built in Bellevue in 1892. This view shows that much of the original timber had been logged off and new growth had begun.

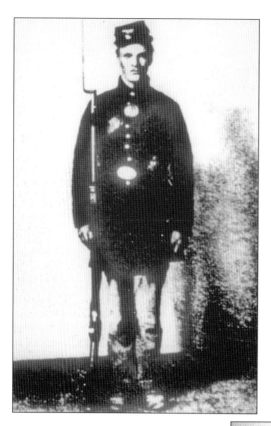

CLARK MERRILL STURTEVANT. Sturtevant was allowed a homestead of 160 acres and in 1872, the Civil War veteran paddled up Mercer Slough and selected a site near 116th Avenue and Northeast Eighth Street. This land included a small lake that became Lake Sturtevant, now called Lake Bellevue. The area was later named Midlakes, as it was located between Lake Washington and Lake Sammamish. He later purchased additional land around the lake for $600. Sturtevant lived in Bellevue for 37 years. He died in 1911.

VICTOR HANSON, C. 1918. Victor Hanson, pictured here in military uniform, served in World War I, and his name is engraved on the Memorial Monument in Downtown Park, Bellevue. He was born July 14, 1893, in Wyanett, Minnesota, the son of Hans and Christine Hanson. They moved to Bellevue in 1917. He died of wounds in France on October 13, 1918.

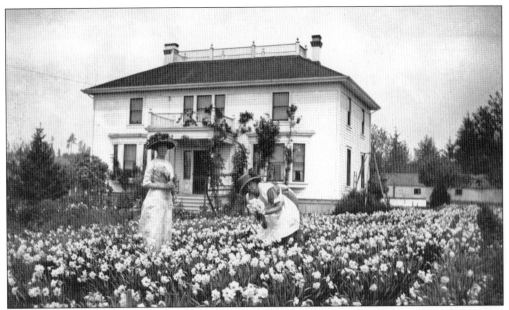

BAKER HOUSE, BELLEVUE, C. 1912. The Cruse-Hill families grew daffodils to sell at the market in Seattle. Their home was located at 100th Avenue and Northeast Eighth Street, where a Quality Food Center (QFC) stands in 2006. In this enchanting picture, Mary Cruse and Grace Hill are picking narcissus. (Phyllis Hill Fenwick collection.)

ALBERT S. BURROWS, 1880s. Albert S. Burrows, a Civil War veteran, arrived in the area from Des Moines, Iowa, in 1882 and homesteaded near the lake, building his cabin in the region now known as the Killarney area of South Bellevue. With the help of George Miller, he built the first school in Bellevue in 1884, and his daughter Calanthia Burrow, then 16, became the first schoolteacher, with seven pupils.

POSTMISTRESS MAY JOHNSON, C. 1895. May Johnson was 41 years old when she worked for the Bellevue Post Office from 1885 to 1896. She rode north two times a week to the Houghton Post Office, where all Eastside mail came by boat. She received $50 a year. Bellevue Square is now located across the street from the pictured location at the intersection of 100th Avenue and Northeast Eighth Street.

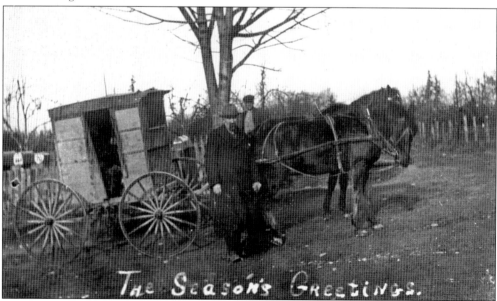

POSTAL DELIVERY WAGON, 1905. Sam Sharpe and Wellington Burr pose with a postal delivery wagon in a Bellevue "Seasons Greetings" postcard.

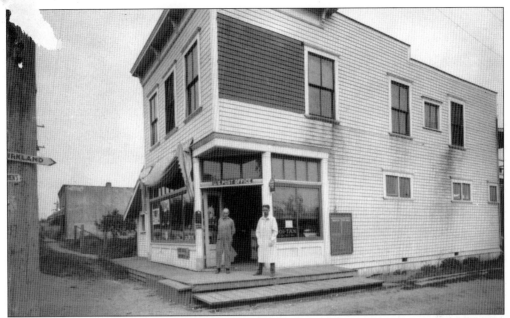

MEDINA GROCERY STORE, 1924. David and Walter Hagenstein stand in front of the Medina Grocery, located on Evergreen Point Road and Northeast Sixth Street. This building is still standing as this book is being published, but will soon be torn down and rebuilt.

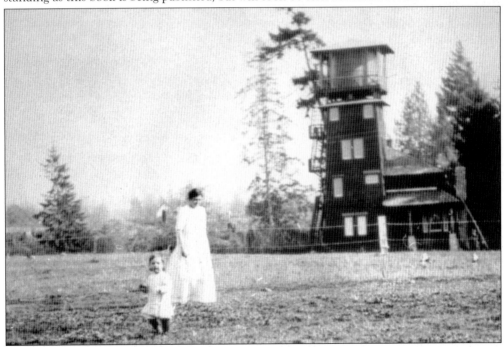

THE TOWER HOUSE, 1914. The Tower House, located near the corner of 97th Avenue and Northeast First Street in Bellevue, was built around 1914 by the Reverend A. B. Strong. A large water tank located at the top of the house supplied the neighbors with water. A small apartment was one floor below, with the family quarters on the main floor. During the 1930s, the water tank was removed, reducing the house to two stories. (Courtesy Pat Groves Sandbo.)

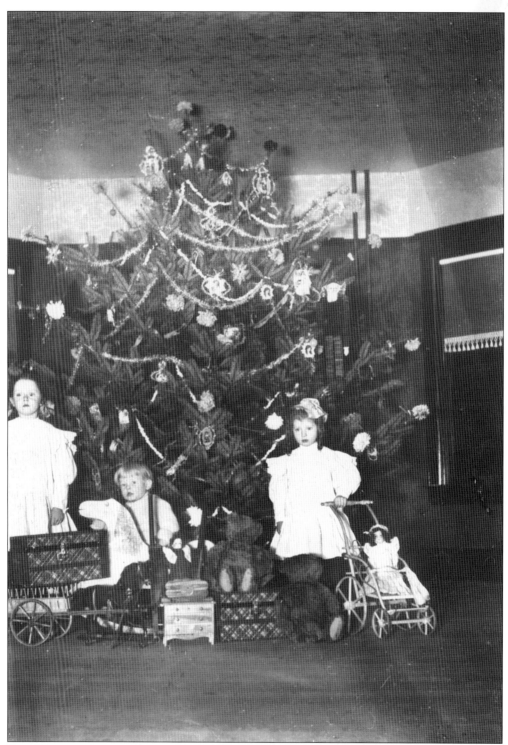

THE BODDY CHILDREN AT CHRISTMAS, C. 1910. Albert and Helen Boddy's daughters Lillian and Viola, and two-year-old Francis, son of Albert's brother John Boddy, show off their Christmas toys in their home at Hunts Point.

MEDINA BABY HOME, 1921. In 1920, a campaign to raise funds for a Medina facility for the care of babies was begun, and a large home with a beautiful view was purchased. The babies were under the care of a staff. This orphanage was at this site until 1926, when they ran out of room and moved the headquarters to Seattle. Studies made at this time soon indicated better methods for infant care and concluded that it was better for the children to be placed in private homes. This well-respected adoption agency is still open in Seattle and now called Amara Parenting and Adoption Services. (Courtesy Amara Parenting and Adoption Services.)

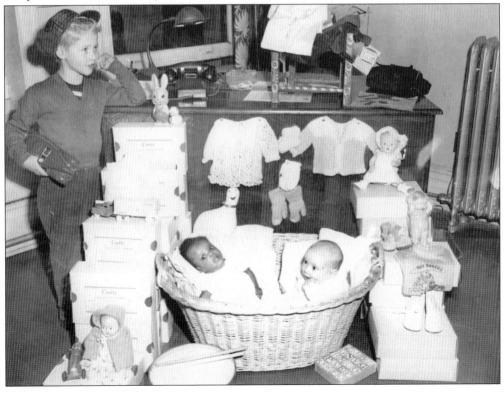

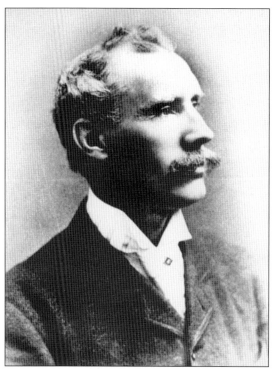

PETER KIRK, 1880s. Peter Kirk of Workington, England, was an established steel mill owner, who auctioned off his property and manor in England in hopes of expanding the family's Moss Bay Company in America. He learned of the iron deposits in the Cascades and of the coal mines in nearby Newcastle, a good fuel source for a mill. The area's economic collapse in 1893 squashed these plans forever, but his namesake city went on to thrive. (Courtesy Kirkland Heritage Society.)

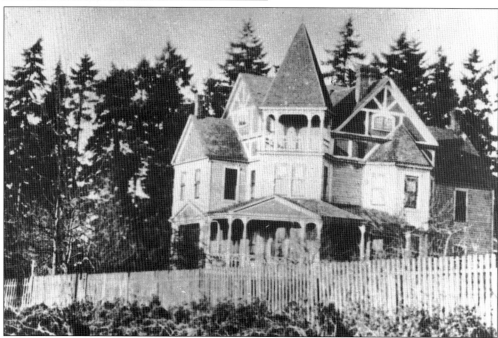

PETER KIRK RESIDENCE, C. 1889. The Kirks built their home in what is now the 200 block of Waverly, in Kirkland. Despite the Panic of 1893, the community prospered, and by 1905, residents petitioned the King County Commissioners to incorporate the community as a fourth-class town. An election was held for the 400 residents. The incorporation vote passed 60–49, and the incorporation document was certified on October 12, 1905.

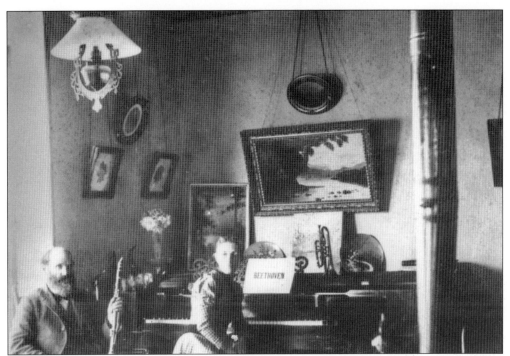

FRANK AND MOLLY CURTIS AT HOME, C. 1890. Frank and Molly pause from playing music in their family home in Houghton. Frank was the captain of the *Squak* and *Elfin*, both of which were built at the lake's shipyards in Houghton. In the 1870s, the Curtis family was one of the major leaders in the growth of the Eastside shipbuilding industry. By 1900, the family owned one of the first transportation services on the lake, building and operating ferries and other boats.

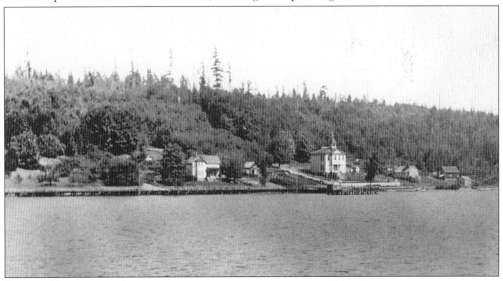

CURTIS HOME AND HOUGHTON (NOW YARROW BAY), C. 1910. This photograph was taken before the Lake Washington Ship Canal lowered the lake by nine feet. The Curtis family was instrumental in the growth of the Kirkland and Houghton areas. The first settlers moved to the Houghton area in the 1860s, where Native Americans once had campsites. Yarrow Bay was another Native American encampment. (Courtesy MOHAI.)

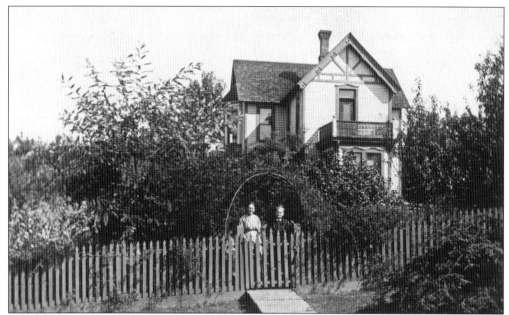

TILLMAN RESIDENCE, C. 1925. The Tillman residence once stood where the Green Funeral Home stands on State Street in Kirkland in 2006. It was moved to "the curve in Redmond Road." Gus H. and Albert Tillman, originally from Kansas, settled in this home with their parents, August and Mary, in Kirkland around 1910. Gus was a truck transfer agent and Albert a truck driver. Albert and his wife, Florence, raised their family in this house.

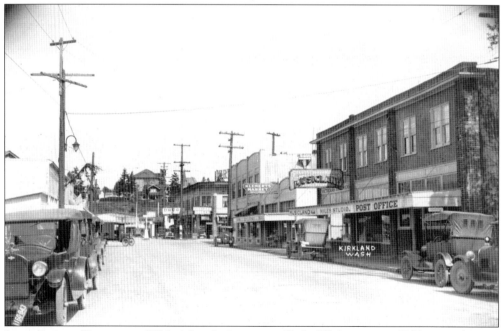

LAKE STREET, KIRKLAND, 1926. After the lowering of Lake Washington in 1917, many changes took place with the new influx of families moving to the area. This brought many new businesses, churches, schools, and industry to Kirkland. This view looks north from the south end of the central business district.

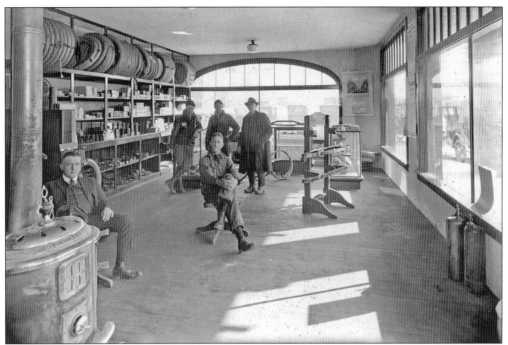

KIRKLAND MOTOR COMPANY, 1925. Pictured is the interior of Kirkland Motor Company, taken in Kirkland around 1925. Seated in unidentified order are Dr. Ruffin and Ollis Patty. The woodburning stove is typical of the era.

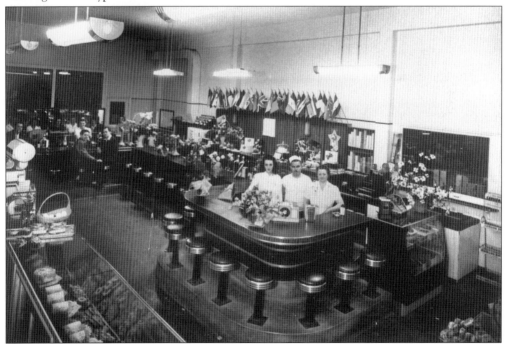

SCHMIDT'S BAKERY, KIRKLAND, 1940. The Schmidt's Bakery interior includes an inviting lunch counter that was frequented by Eastside customers. Service businesses blossomed as residents moved to the Kirkland, Redmond, and Bellevue communities.

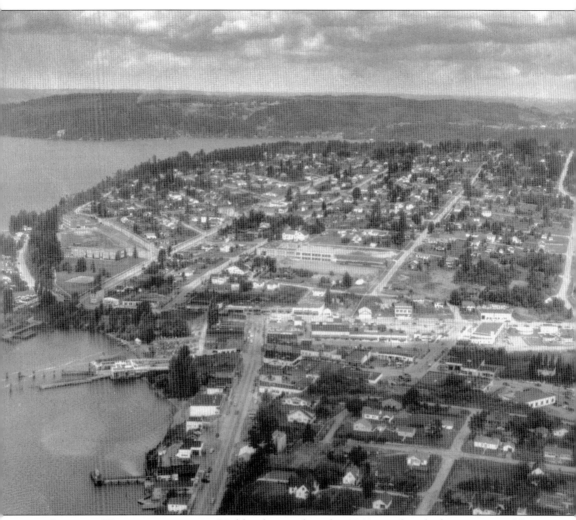

CENTRAL KIRKLAND, C. 1940. Kirkland started in the 1860s, and with the increase of ferry service in the 1920s, began to boom. The Lake Washington Shipyards became a major source for the war effort during World War II. Industry, such as the woolen mill, also supported Kirkland's growth. The marina is in the lower left, and the junior high school, which burned down in the 1970s, can be seen north of it.

MERCER SLOUGH-PHANTOM LAKE SCHOOL, 1890S. This log cabin was located near the trail to the body of water at Mercer Sough. In December 1893, settlers successfully petitioned for the school, which started early the following year in an abandoned bachelor's cabin in a clearing. Helen Thode Boddy related that the cracks between the floor boards were so wide, skunks used to come up looking for crumbs when they ate lunch. Their biggest fear was of the bears in the area. The teacher was Miss Conway. (Rosemary Kramer collection.)

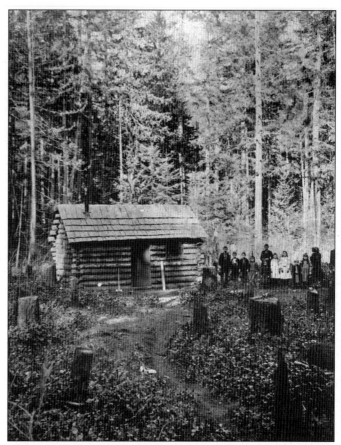

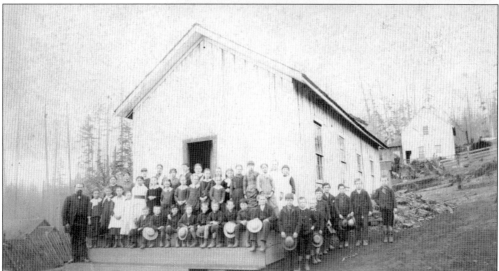

NEWCASTLE SCHOOL, C. 1882. This is a very early photograph of Newcastle School, where George Colman attended. George is the fourth person from the right. This photograph was one of the Colman photographs donated to Eastside Heritage Center by the Fawcett family of Kennydale. (Colman collection.)

KIRKLAND HIGH SCHOOL GRADUATES, C. 1902. Elegantly dressed students are seen in this graduation ceremony photograph taken around 1902. (Courtesy Fred V. Glover.)

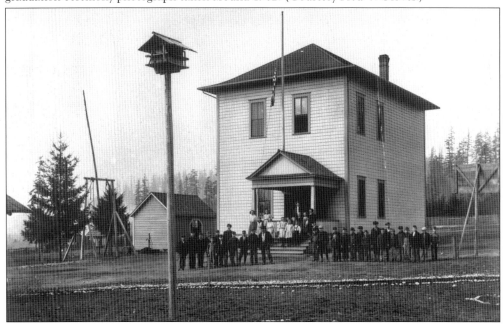

JUANITA SCHOOL, 1909. Students are standing in front of Juanita School. There is an interesting birdhouse in the front yard. This photograph was taken by Person and Company, Seattle.

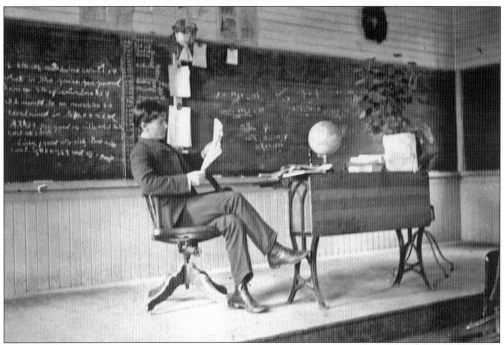

WILL SHANNON AT JUANITA SCHOOL, 1903. Schoolteacher Will Shannon looks over his notes for a day in his Juanita classroom in March 1903. The school was located in school district No. 21, one half mile east of the town of Juanita.

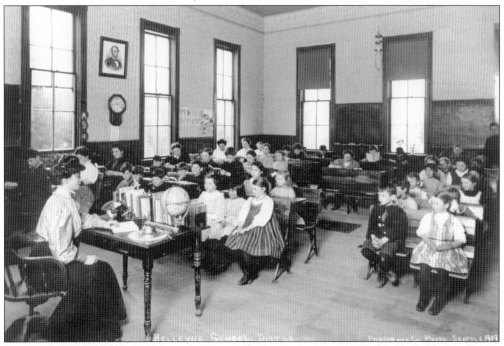

BELLEVUE SCHOOL CLASSROOM, 1909. This is a rare interior photograph of a classroom in Bellevue. In 1892, this school was erected on present-day 100th Avenue and Main Street, beginning with two rooms and a bell tower. Another section was added to the school in 1909. (Courtesy UW.)

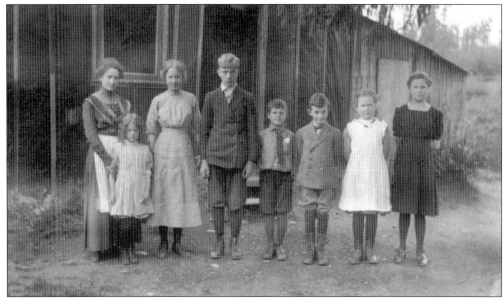

BEAUX ARTS SCHOOL, 1911. The entire student body poses in front of the school, which stood at 3103–3107 108th Avenue SE and was in Bellevue School District No. 49. Pictured, from left to right, are teacher Ada B. Esty, Margaret Clewley, Emma Whaley, Russell Whaley, Palmer G Lewis, Harold Pontius, Barbara Whaley, and Helen Whaley, who married James S Ditty. Once the children reached eighth grade, they went to school in Bellevue. (Palmer Lewis collection.)

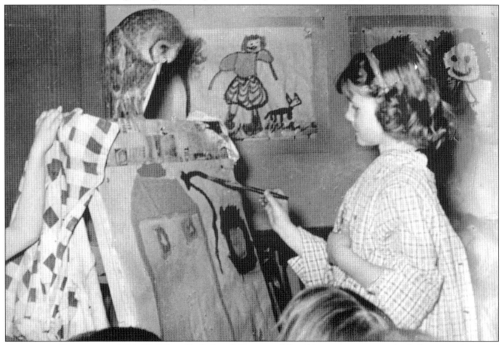

CENTRAL SCHOOL, 1937. Kirkland's School District No. 71 was very proud of the new Central School, which was a Works Progress Administration project. Barney Big Eyes the owl was a beloved pet in the kindergarten classroom of Mrs. Wiggins. He lived with Mrs. Wiggins after she retired.

BLACK CHURCH AT KENNYDALE, C. 1890S. African American families arrived at the coal mines of Newcastle, Kennydale, and Coal Creek in 1891 and numbered more than 1,000 by the end of the 19th century in King County. In 1900, the Colored Baptist Association was formed at Newcastle. Seattle African Americans enjoyed an annual picnic held by the Fraternal Order of the Hawks, a mutual benefit society. Picnickers boarded the morning *Leschi* ferry and enjoyed a full day of food, friends, and fun. (Courtesy Renton Historical Society.)

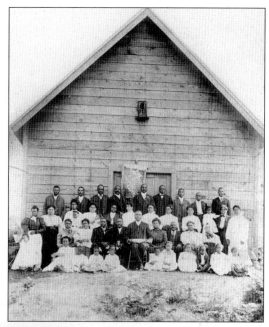

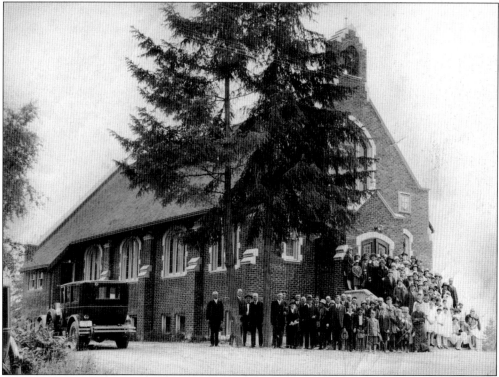

SACRED HEART CHURCH, 1927. Bellevue's first Catholic church was established as a mission associated with Kirkland's Holy Family parish. Its first services were held in the parlor of the Downey family home in 1913. The congregation moved into a small wooden building on Main Street near 108th Avenue Northeast, and the brick building in this image was built in 1926. It later housed the Bellevue Public Library. It is now the Scott Oki Foundation.

FIRST BAPTIST CHURCH, 1950S. Bellevue's second church was the Baptist church located on 100th Avenue and Northeast Eighth Street, which functioned as a church from 1900 to 1960. The Reverend J. G. Baker held his first service in the parlor of the big white house built by his son-in-law Corwin Shank, a Seattle attorney. It was on a 40-acre tack of land, and Shank reserved a log cabin on the grounds as a summer retreat for his own family. The two structures shared a well, a three-hole outhouse, a barn, pig pen, chicken house, and rabbitry. Later Baker erected a church a few hundred feet north of the log cabin, facing 100th Avenue. It is now a teen center for the Bellevue Boys and Girls Club, across from the Downtown Park.

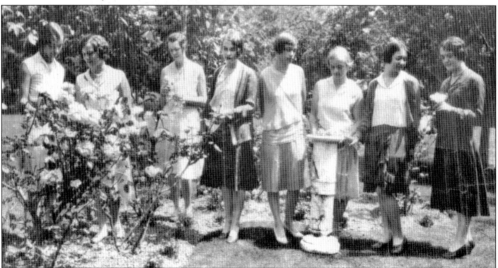

OVERLAKE FRUIT AND FLOWER MISSION, 1920S. The Overlake Mission was probably Bellevue's first social service agency and was formed for the purpose of distributing fruit and flowers to the sick. Junior members sometimes sponsored families at holiday time and provided them with food and clothing. During the Depression, the organization became the Milk Fund and eventually became the Overlake Service League. (Phyllis Hill Fenwick collection.)

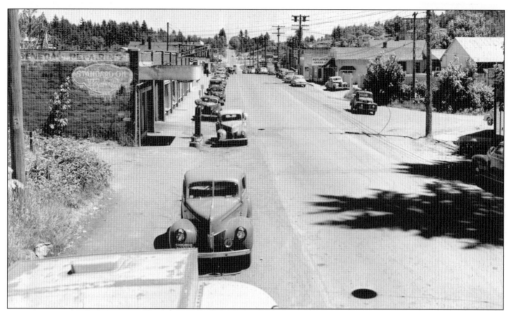

MAIN STREET BELLEVUE, C. 1930. In these days, Bellevue had no town government and no fire department. In 1935, Kirkland was called upon to put out the huge fire at the American Pacific Whaling Company at Meydenbauer Bay. Bellevue was very much a farming community. The city incorporated in 1953. (Courtesy MOHAI.)

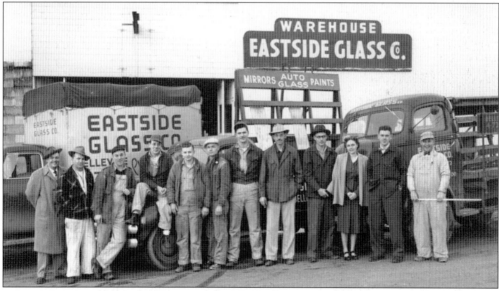

EASTSIDE GLASS COMPANY, 1953. In 1946, Paul and Reda Vander Hoek purchased and moved the Eastside Glass Company to 10245 Main Street. Pictured, from left to right, are Jack Silvain, unidentified, Leonard Dodmann, George Strain, Harold Sturm, Jim Lindstrom, Bob Knuckey, Bud Vander Hoek, Paul Vander Hoek, Reda Vander Hoek, Ed Keenholtz, and unidentified. The business eventually included paint, auto glass, and wall and floor coverings. Son Ted eventually managed the residential window area, Lanny managed the commercial glass department, and Stu managed the retail store. In 1988, the brothers formed Vander Hoek Corporation to manage the family's real estate holdings and to develop new buildings. (Courtesy Paul Vander Hoek.)

59

BELLEVUE STRAWBERRY FESTIVAL, 1932. Japanese princesses entertain the crowd at the Strawberry Festival. The first Strawberry Festival was held in 1925 and attracted 3,000 visitors. The festivals ended in 1942 following the internment of the Japanese Americans, many of whose berry crops were the key festival ingredient. In 1987, the Bellevue Historical Society revived the festival. Since 2003, Eastside Heritage Center has sponsored it. In 2005, more than 20,000 people attended from all over King County.

FESTIVAL QUEEN, 1938. The caption on this newspaper clipping reads, "Unique in festivals is that ruled over by Queen Dorothea Robison. She is Strawberry Queen of the 14th annual Strawberry Festival opening today at Bellevue on the eastern shore of Lake Washington. Dedication of a new lakeshore park, fireworks and boat racing are part of the three-day program."

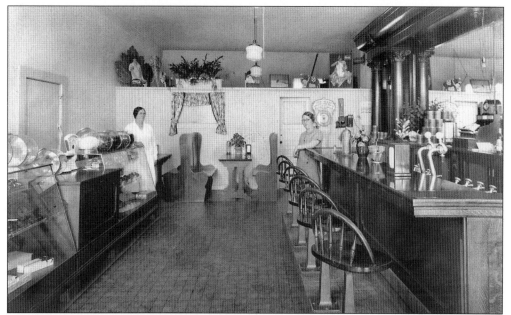

YOUNGER'S MINTS, C. 1930. Addie Hurley and Gladys Younger pose in Charley Younger's candy shop. The Younger family's taffy recipe resulted in the famous "melt in your mouth" Younger's Mints. It was started in the basement of the Younger home in 1926 and later opened in the original McKee building on Main Street in Bellevue. The business later moved to Kirkland and was sold to the Anderson family in 1946.

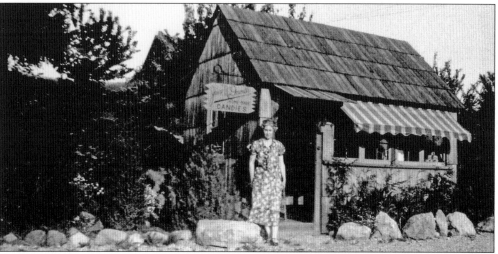

JANE MCDOWELL CANDY SHOP, 1930. Elmina Mary (McDowell) Schafer started making candy out of her home that was built in 1918 on top of the hill looking over 104th Avenue, (now Bellevue Way) and Northeast 24th Street. In the beginning, customers would ring a bell at the bottom of the hill and she would run down to wait on them. As the business grew her daughter Marguerite and daughter-in-law Violet helped out. Her husband, Louis, made peanut brittle and butter mints, while Mina made and dipped chocolates in the back room of the cottage. This was a heavenly smell and treat for the grandchildren. Her candy even graced the White House during Pres. Franklin Roosevelt's term. After Louis's death in 1952, the business was sold and became the Kandy Kottage. (Diana Schafer Ford collection.)

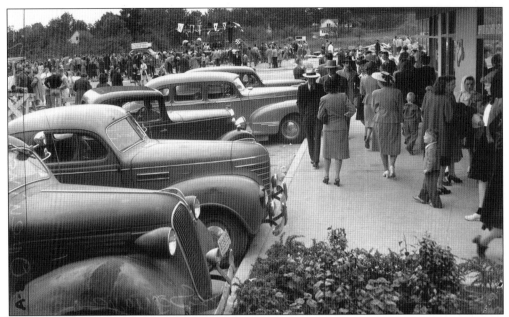

BELLEVUE SQUARE OPENING, MAY 19, 1947. Bellevue's population at this time was only 9,000 people. Kemper Freeman Sr. envisioned a movie theater in Bellevue, and he fulfilled his dream of building a shopping center with free parking. The combination of the Lake Washington Floating Bridge and good shopping brought many new residents and visitors to the Eastside. (Courtesy MOHAI.)

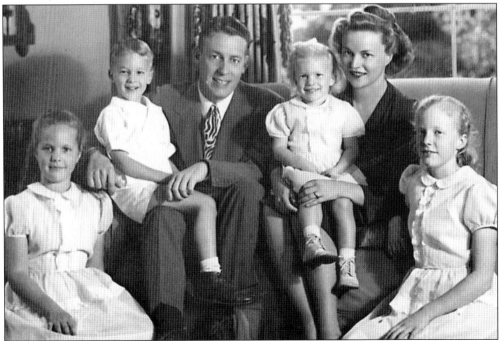

KEMPER FREEMAN SR. FAMILY, 1940S. Kemper Freeman and Clo Duryee married on May 26, 1933. They are pictured here with their children (left to right) Coco, Kemper Jr., Elizabeth, and Sarah. (Courtesy Kemper Freeman Jr.)

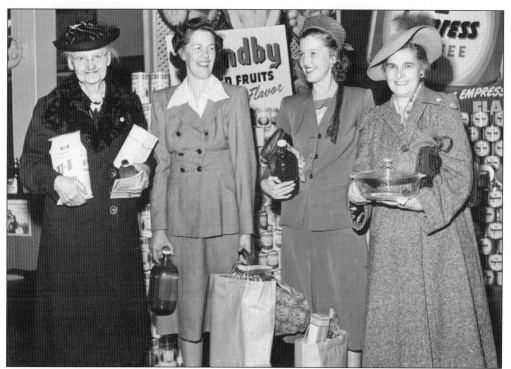

LAKESIDE SUPERMARKET, 1944. In these days, women dressed up for grocery shopping. Pictured here, from left to right, are Tina Rudulph, Lucille Birdseye, Gladys Burnell, and Myrtle Carr Burnell, enjoying themselves while shopping at Lakeside Supermarket in Bellevue. (Bill Brant collection.)

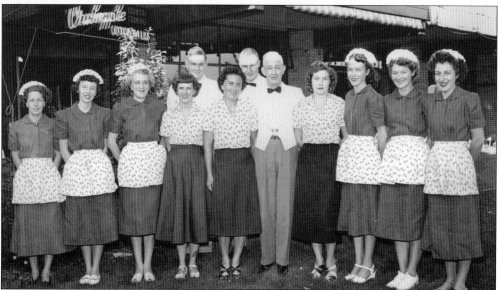

CRABAPPLE RESTAURANT EMPLOYEES, C. 1950. Owner Charles Pefley and his employees stand in front of the Crabapple Restaurant in the Bellevue Shopping Square. The Crabapple was a local landmark, known for grand dining, as a meeting place, and for its famous Madrona tree. People traveled for miles to visit the restaurant. (Pefley collection.)

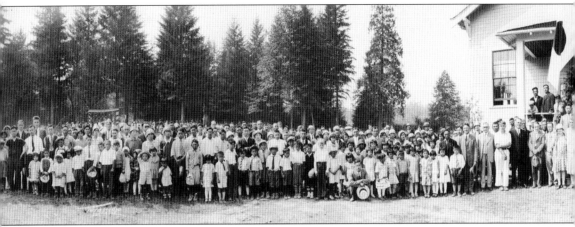

KOKAIDO JAPANESE CLUBHOUSE, BELLEVUE, 1930. In 1930, the local Japanese community of approximately 300 residents built a clubhouse near 102nd Avenue and Northeast 10th Street. An estimated 500 people, including Bellevue's leading citizens, as well as friends and relatives from Seattle, attended the dedication. The clubhouse served as a meeting place for businesses, Buddhist

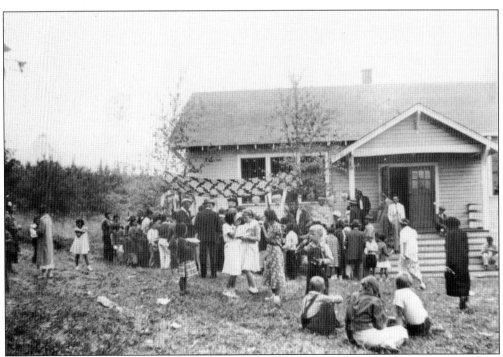

PICNIC AT THE CLUBHOUSE, 1937. Families often got together for picnics, spending the whole day. They had lots of food, played games, and enjoyed music and Japanese dancing. (Courtesy Mitzie Takeshita Hashiguchi.)

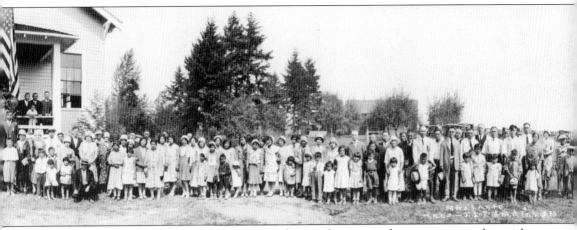

and Christian church services, classes, movies, plays, and various indoor activities, such as girls and boys' basketball, judo, and Kendo. Football and baseball teams and annual community picnics were also organized. With Executive Order No. 9066, more than 400 local Japanese Americans were sent to internment camps in Idaho and California.

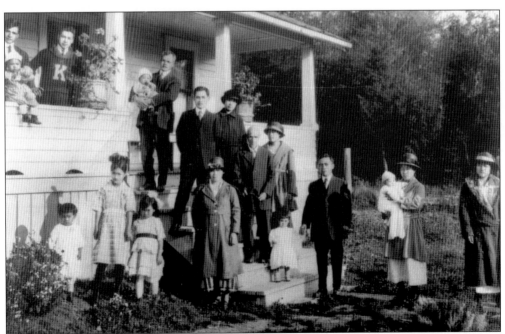

THE TERUMATSU YABUKI FAMILY, 1920s. The Yabuki home and greenhouses were located near Hunts Point at 84th Avenue and Northeast 28th Street. The family was being visited by friends from Japan. Terumatsu moved from Japan to this county in 1911 at age 18. He is on the porch, far left, holding a baby. In this part of Bellevue, students attended Kirkland High School, as indicated by the "K" on the young man's sweater, second from left, on the porch.

AIR RAID DRILL, 1941. Sisters-in-law Winifred (Evans), left, and Violet (Cort) Schafer took part in the civil defense training at the Bellevue Union High School during World War II. Bellevue volunteers staffed an aircraft observation tower rising high above Vuecrest on a round-the-clock watch for enemy planes. (Diana Schafer Ford collection.)

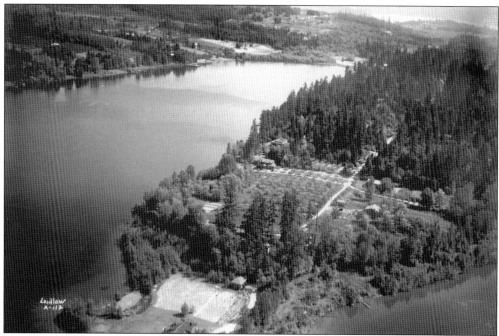

HUNTS POINT, 1931. This aerial photograph of Hunts Point from the northwest was taken by Charles Laidlow in 1931. At the time, the area was a farming community. In earlier times, the Sammamish Indians used it for a camping ground. In the early 1880s, Leigh S. J. Hunt purchased the land from an old homesteader and named the land after himself. Today it is a community of millionaires from the dot-com age. (Courtesy MOHAI.)

Four
AN AGRICULTURAL LEGACY

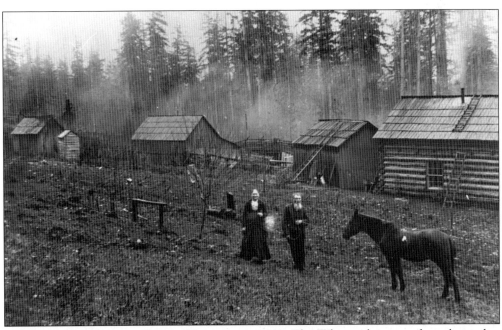

DANIEL AND SARA JANE GREEN WHITNEY, C. 1887. The Whitney homestead was located at 124th Avenue Northeast and Northup Way. The horse's name was Charley. Though the cabin appears rustic, with large chinks between logs, the windows are double-hung with many panes, and the structure has two stories. The presence of ladders on two buildings implies frequent roof leaks through the large cedar shingles. The fences are split rail with sawbucks; some are wire. Daniel (1808–1902) and Sarah (1825–1901) are laid to rest in the Kirkland Cemetery. From the lakeshore east, years of backbreaking work ultimately cleared hundreds of acres of fertile, bountiful farm fields. Farmers took their produce to the lakeside docks and ferried it across to the public market in Seattle. Some found markets even farther away, sending it to other states and even outside the country. Today the land is covered by housing developments, malls, and freeways.

1. Vander Hoek Farm
2. Shiraishi Farm
3. Richards Farm
4. Tamura / Inatsu Farm
5. Flynn Wildwood / Havercamp Dairy
6. Balatico Fruit and Vegetable Farm
7. Smith Farm
8. Reece Bulb Farm
9. Winters Farm
10. Ostbo King of Shrubs Nursery
11. Kelfner Vineyard
12. Reid LaBelle Fruit and Flower Farm
13. Matsuzawa / Suzuki Farm
14. Sakaguchi Farm
15. Hirotaka Farm
16. Calloway-Haas Ledges Greenhouses
17. Martin Farm
18. Campbell / Stetson / Hamley Fruit and Vegetable Farm
19. Bechtel Homestead
20. Peterson Farm
21. Warren Farm
22. Rose Chicken Farm / Sydnor Blueberry Farm
23. Burr Farm
24. Sharpe Farm
25. Gordon "Bonnie Brae" Farm
26. Numoto Farm
27. Cruse / Hill Farm / Brunton Horse Farm
28. Clarke Vineyard
29. Loughran Vineyard
30. Simpson Vineyard
31. Hennig Vineyard
32. Downey Homestead
33. Edwards Lily Garden
34. Stryker Farm
35. Jewell Farm
36. Borg Vineyard
37. Gilmore Bros. Fox Farm
38. Mink Ranch
39. Delkin Bulb Farm
40. Boddy Dairy / Yabuki Greenhouses
41. Tsushima Farm
42. Numoto Farm
43. Potier Argyll Fruit Farm
44. Muromoto / Mizokawa Farm
45. Tremper Holly Farm
46. Ishida / Baba Farm
47. Bechtel Homestead
48. Minette Dairy
49. Zwiefelhofer Homestead
50. Goff / Whitney Homestead
51. Multiple Family Farms: Hirai, Yamagiwa, Fuwa, Hayashida, Aramaki, Suguro, Takeshita, Hashiguchi, Mashiyama
52. Bellevue Growers Assoc. Packing and Shipping Warehouse
53. Sharp Homestead / Davijian Farm
54. Kodani Farm
55. Kawakami Farm
56. Twin Valley Duey Dairy / Fisher Cattle Ranch
57. Silliman Benhurst Dairy
58. Peterson Hill Mulitple Family Farms: Yoshino, Tamaye, Yamaguchi, Nomura, Tamate, Shimogaki, Kamichara,
59. Ito Farm
60. Allen Farm
61. Tanino Farm
62. Morelli Bros. Chicken Farm
63. Seipmann Highland Dairy Farm
64. Skinner Farm
65. Swanson Farm
66. Carlsen Chicken Farm
67. Peterson Farm
68. Early Marymoor Dairy Farm
69. Aries Farm
70. Larsen Homestead / Blueberry Farm
71. Nelson Phantom Lake Dairy
72. Berndt Farm
73. Masunaga / Matsuoka Farm
74. Miller Homestead
75. Hays Turkery Farm
76. Hutchinson Farm
77. Matsuzawa Farm
78. Downie Farm
79. Evers Farm
80. Jackson Farm

These Bellevue farms, dairies, and vineyards correspond to the "Grown in Bellevue" map on the opposite page.

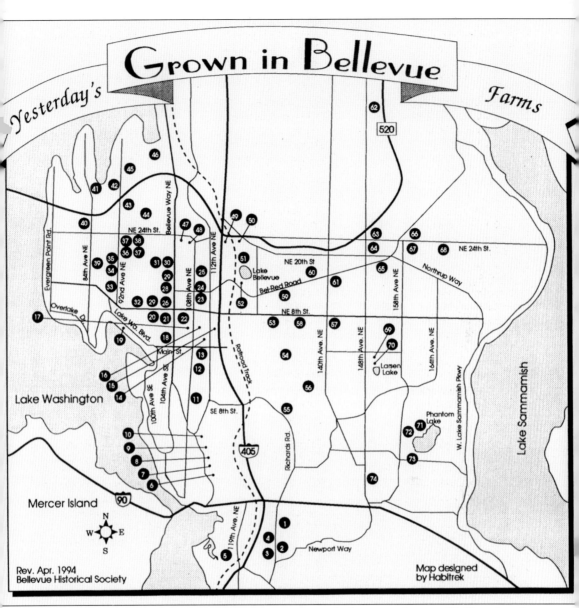

"GROWN IN BELLEVUE" MAP, C. 1994. This map shows the location of many of Bellevue's early farms over an extended period of time before 1942. This information was gathered by the Bellevue Historical Society (now Eastside Heritage Center) from written histories and, when possible, memories of descendants of first generation farming families.

ANDREW NELSON HOMESTEAD, 1912. Located at the intersection of Fourth Avenue and Northeast First Street in Kirkland on the hillside above Lake Washington, this view to the south includes a steamer on the water. This homestead, one of Kirkland's first, is a good example of subsistence farming, versus the commercial farming that would develop in the area once the many old growth tree stumps had been removed. Across the lake is Seattle's Sand Point.

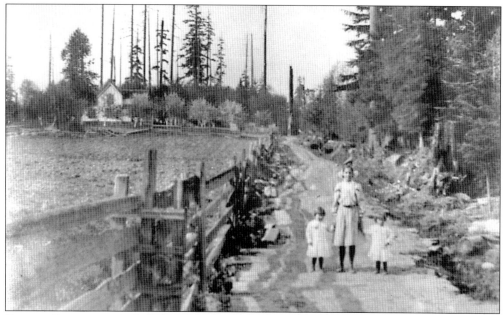

SHARPE FAMILY, C. 1907. Pictured here is Ruby Sharpe with twins Andy and Tom at 108th Avenue and Northeast Eighth Street, looking north. The site is in front of the farm owned by their uncle Charlie Gordon. Andy was one year old when he moved with his family in 1905 from North Dakota. Father Sam worked at the Hewitt and Lea lumber mill until 1911, when he started delivering mail as the second carrier in Bellevue. The Sharpes lived nearby on a farm at 108th Avenue and Northeast 12th Street, where they had livestock and a vegetable garden. Andy became an electrical contractor. He was Bellevue's longest living citizen when he died at age 93 in 1998. (Burrows collection.)

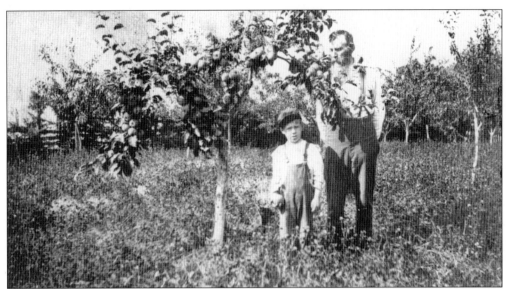

J. B. Warren and Grandson Albert W. Burrows, c. 1904. The apple crop is producing on both younger and more mature trees. The cover crop on the ground looks like clover, an interesting cultural practice. This orchard is located at the present-day site of Bellevue Square.

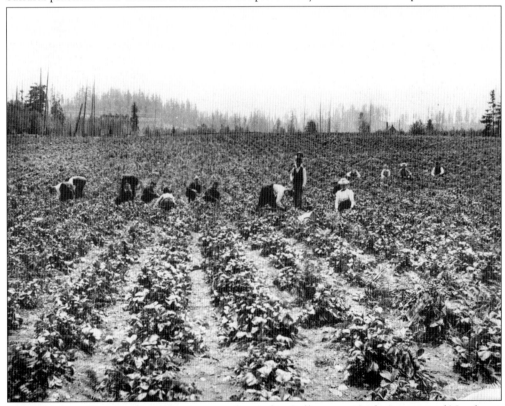

Jesse Warren Farm, 1904. This farm was located in Bellevue at 104th Avenue and Northeast Eighth Street, now the site of the upscale shopping mall Bellevue Square. This is a strawberry field, but curiously, the pickers have no baskets or carriers. They are also wearing rather formal dress.

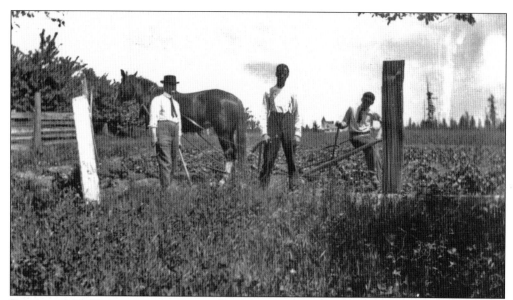

BURROWS MEN FARMING, 1912. Pictured with Kit the horse, from left to right, are Charles Myers, Albert Selden Burrows, and Albert Warren Burrows. It could be that two of the men are fence maintainers chatting with a field worker. The tools pictured include a horse cultivator, a bow saw, and a hammer. The orchard is nearby. The site pictured is near where Bellevue Square is today, and the view is to the east, with the Congregational Church just visible in the background.

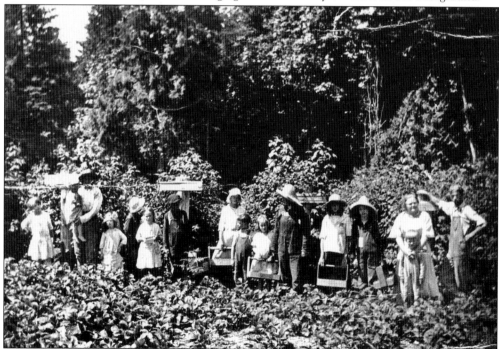

STRAWBERRY PICKERS IN JUANITA. On the Emil Engebrekt (other spellings found include Engbrecht, Engebrekt, Englebrecht, and Englebrekt) Berry Farm in Juanita, men, women, and children with flats prepare to pick strawberries. This farm, located near Northeast 130th Place, Juanita, is a good example of the farms hewn from dense forest.

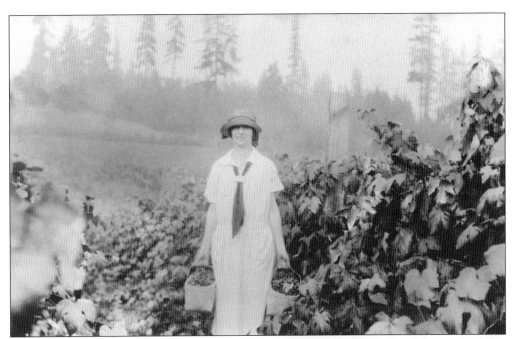

NELLIE WEBER (ABOVE) AND ADOLPH HENNIG, C. 1925. The Hennig's vineyard was located on a Clyde Hill hillside above the present location of First Presbyterian Church in Bellevue. Their use of small baskets indicates they were probably picking for the fresh market. This style of basket appears often. In contrast, picking for juice was a high volume effort that continued seven days a week until finished. Hennig's was one of several vineyards in neighborhood. Clarke, Loughran, and Simpson also had vineyards west of Bellevue Way. Clark and Loughran each operated a roadside stand for selling grape juice, corn, and other produce. One year, the Loughrans sold 5,000 gallons of juice, mostly from the stand, produced from only two and a half acres of grapes.

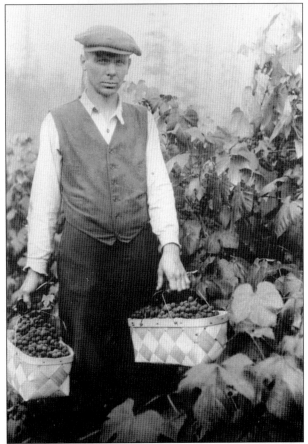

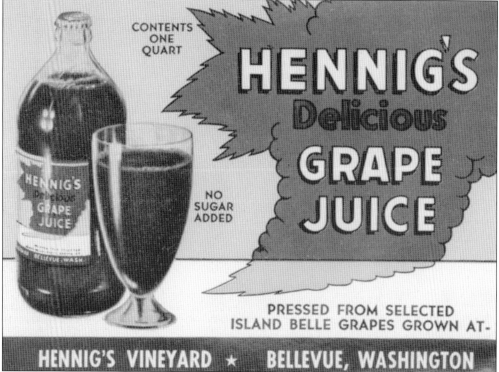

HENNIG'S GRAPE JUICE LABEL, MID-1920S. This label boasts the Island Belle grape variety, which thrived in the lakeside climate. Adolph Hennig designed and built his own equipment for extracting and pasteurizing juice. Penniless when he first came to Bellevue, he managed to procure a three-acre parcel and later bought a five-acre parcel with a one dollar down payment. He eventually paid it all off. During harvest season, the grape juice plant ran 24 hours a day nonstop until the crop was all in.

PHILIP HENNIG, C. 1925. The Hennig's Model T Ford truck has an open cab with a flare-sided bed. Philip appears to be sneaking some grapes. By 1929, due to competition and the Depression, grapes brought only 1¢ per pound, so Hennig started making grape juice, which he could market year-round. He designed and built his own processing equipment. The trees are second-growth timber looking across 100th Avenue at Northeast 19th Street.

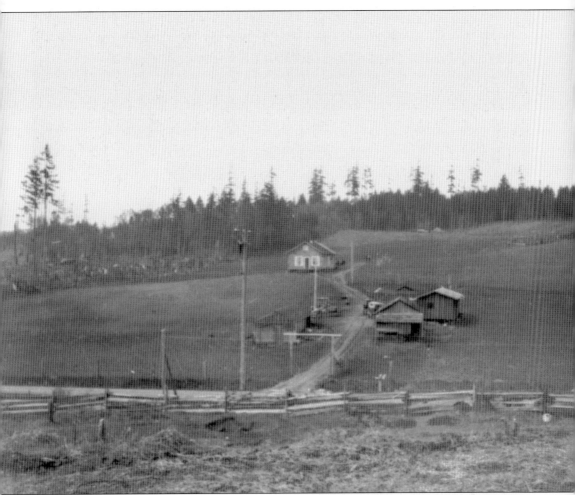

JOHN C. CLARKE HOME, 1920 OR 1921. This view is of Bellevue Way at Northeast 18th Street, looking west. Trees surround the field, which was, as were all local farm fields, hewn from the forest. Slashed and fallen trees are typical of woodlands after logging. It was the farmer's burden to clear up this debris, remove stumps, and plow up roots before the field was suitable for cultivation. This was very difficult work. Since many farmers typically leased for five years, by the time they had the land cleared, they were forced to move to a new location and start clearing all over again.

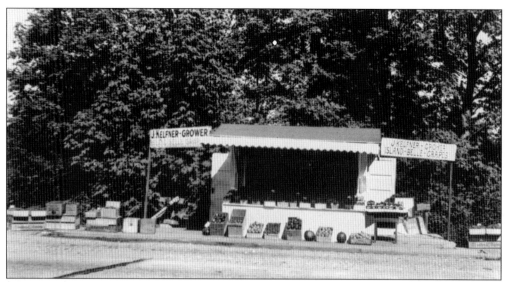

J. Kelfner Fruit and Vegetable Stand. This stand offers Island Belle grapes for sale. In 1912, John J. Kelfner started farming on a 10-acre tract at 108th Avenue and Southeast Eighth Street in Bellevue. He bought his first grape cuttings from a man named Eckard on Vashon Island and propagated grape vines in the basement of his house. One year during the 1930s, he sold nine tons of grapes to a single buyer. (Kelfner/Sharpe collection.)

Aries Farm Seeding, c. 1913. The men used popular push seeders such as Planet Junior. The Aries farm property ran from Larsen Lake north to Northeast Eighth Street, where it adjoined the Skinner property (formerly Churchill). The seed is possibly lettuce. The Aries farm produced cabbage, corn, squash, peas, potatoes, wax beans, cauliflower, carrots, celery, and most importantly iceberg lettuce, which found markets as far away as the Philippine Islands, Alaska, and the Yukon Territory. (Aries collection.)

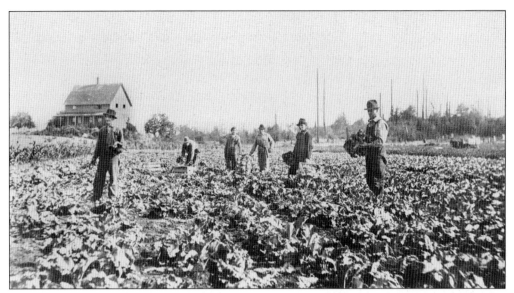

ARIES FARM, LARSEN LAKE, 1920. Ove and Mary Larsen, who gave their name to the lake, later sold their farm to the Aries family—Louis, Tony, and Albert, who came from South Park in Seattle. These workers are crating lettuce for market. One worker has a hammer for closing crates. This farm was located near the former Kmart plaza on 148th Avenue Southeast and Main Street. There is a substantial house in the background. The snags (tall tree trunks) are typical of those left by loggers. (Aries collection.)

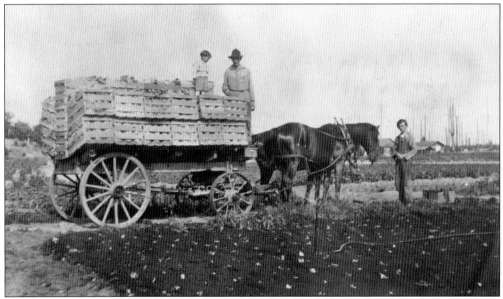

ARIES FARM WAGON, 1918. This wagon, carrying lettuce, has a slanted deck and steel front wheels with wooden rear wheels, an unusual combination. At peak production, the Aries brothers shipped seven railroad carloads of lettuce. Four went to Minneapolis, the rest to Montana. They produced 4,000 sacks of potatoes; some went to Dawson, Yukon Territory, the rest to points in Alaska. The Aries brothers farmed early on by hand and horse. They later used a Pope Hartford truck capable of six miles per hour. (Aries collection.)

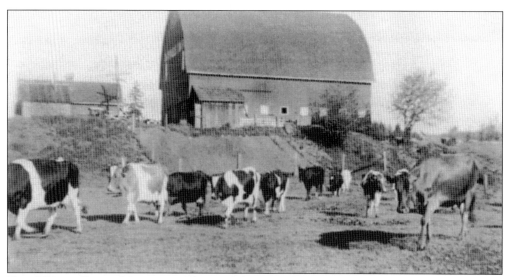

TWIN VALLEY DAIRY, MID-1930S. This south barn, used for cattle, had 28 stanchions for milking. The much smaller adjacent barn was a milk house for cleaning milking machines and processing raw milk. The dairy was started by the W. H. Duey family, who moved from Mount Vernon, Washington, in 1921. A later owner, John Michael, built the north barn in 1943. It is currently Kelsey Creek Farm, a public park in Bellevue. (Duey collection.)

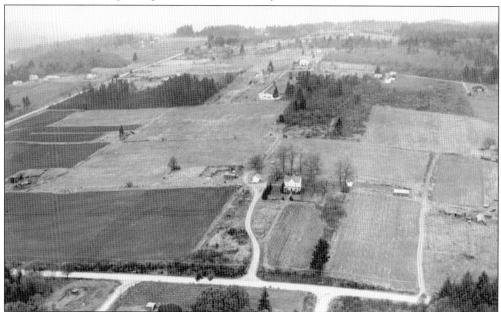

PATRICK DOWNEY FARM, 1930. Patrick Joseph Downey and his wife, Victoria Marie Downey, settled in 1882, built the house in 1896, and leased much of the farm to Japanese farmers. The farm was located on the south end of Clyde Hill, now in the Vuecrest neighborhood. The Downeys had 13 children, and the eighth child, Sr. Margaret Jane Downey, was the first to be born in the house. The view is looking north. The road running left to right in foreground is Northeast Eighth Street; 92nd Avenue Northeast is in the upper left-hand corner. Numerous half-acre or one-acre plots are visible, probably used in rotation. Woodlands and cane crops or vineyards are also visible. (Kelfner/Sharpe collection.)

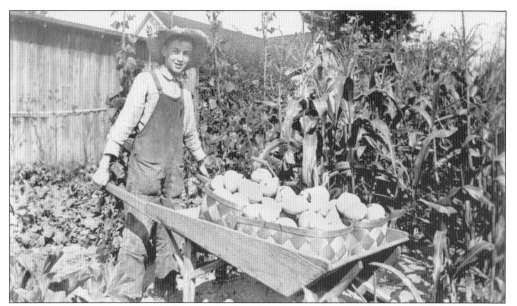

FRED HAMLEY, C. 1918. Fred is shown on his grandfather Stetson's farm. The baskets are typical harvesting baskets. The vegetable may be a kind of summer squash, such as pattypan or scallop. This location is near Downtown Park, south of Bellevue Square. (Courtesy Hamley family.)

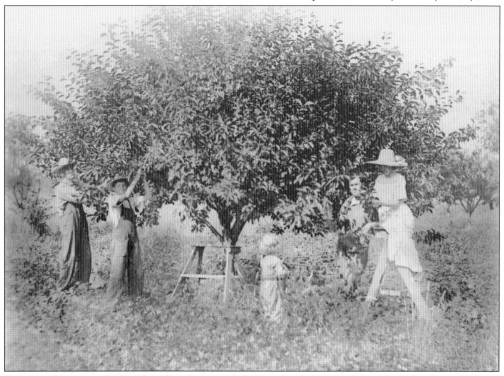

STETSON FARM, C. 1918. Llewellyn Stetson, left, his grandson Charles or Fred Hamley, and three other unidentified people seem to be picking cherries, but they have no baskets, so the photograph may be posed. This location is now the north end of Downtown Park, south of Bellevue Square. (Courtesy Hamley family.)

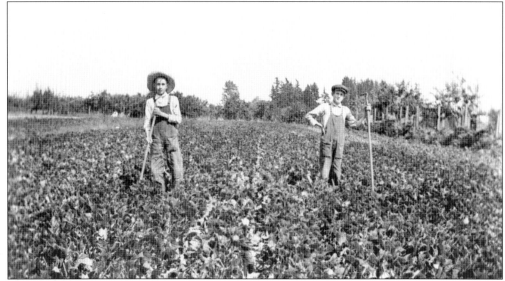

HAMLEY BROTHERS, C. 1918. Llewellyn Stetson came from Minnetonka, Minnesota, after the great Seattle fire, and he bought 10 acres near the Downtown Park area. The Hamley boys, Charles and Fred, were raised by their grandparents while their mother worked as a silent movie pianist in Seattle. (Courtesy Hamley family.)

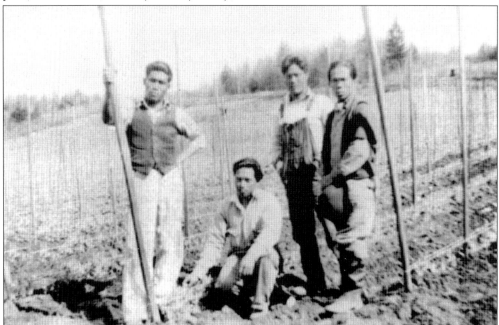

BALATICO FARM, MERCER SLOUGH. Andrew Balatico is third from left; brother Marceliano is at far left. The other two are hands hired for a pea harvest. Andrew moved from the Philippines in 1926 at age 20 and worked on the railroad. He eventually purchased several acres in the slough in the late 1930s and later bought another 20 with Marceliano, which they farmed until 1985. A major task in farming the slough was to remove stumps, limbs, and roots that were buried in the soil. During the war, Andrew took over operation of some of the plantings of his Japanese neighbors when they were interned. (Courtesy Balatico family.)

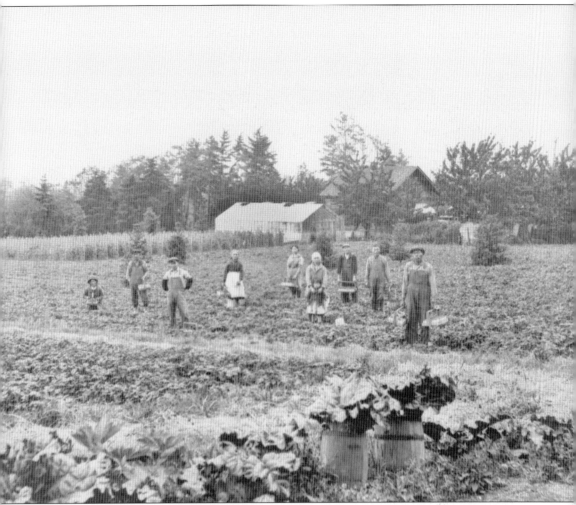

NUMOTO FARM, 1925. Cano Numoto managed this farm started by his father, Tsuruichi Numoto. Identified in the photograph above are Cano Numoto, third from right; Father Tsuruichi Numoto, second from right; Mother Yoshie Numoto, kneeling far left; and Frank Yabuki, third from left. Others are Clyde Hill workers or people hired from Seattle. The farm, located on 92nd Avenue and Northeast 34th Street, produced strawberries, peas, bing cherries, rhubarb, tomatoes, beans, and lettuce. Visible are an orchard, pea vines, and greenhouses. The pickers hold strawberry flats. In 1932, Cano expanded the operation by building two large greenhouses to grow cucumbers. Bellevue at this time boasted hundreds of acres of strawberry fields, which produced a fresh crop sold at the public markets in Seattle. Ninety-five percent of the berries were produced on Japanese farms, using intensive hand labor on small acreage. (Courtesy Numoto collection.)

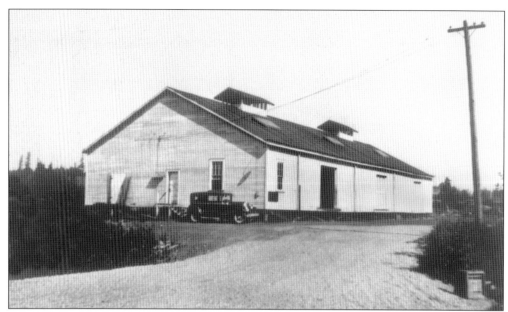

BELLEVUE GROWERS ASSOCIATION PACKING SHED, C. 1933. Led by Tom Matsuoka, below with his sons Tyrus and Tatsuo, the association built the shed in 1933 in the Midlakes area at 117th Avenue and Northeast 10th Street, adjacent to a railroad siding and near the productive Midlakes Japanese farms. The building was used to process produce for shipment in refrigerated railcars. Block ice was hauled in, chipped by machine, and loaded into the cars. The produce was selected, packaged, and placed in the cars. As many as 50 boxcars were shipped out during the summer season. Tomatoes, strawberries, peas, lettuce, tomatoes, and cabbage were primary products, but pole beans, cucumbers, celery, and cauliflower were also shipped. The association's success created a new era of prosperity for the Japanese growers. Membership totaled 60 families, most of who were taken away to camps in Idaho and California during World War II.

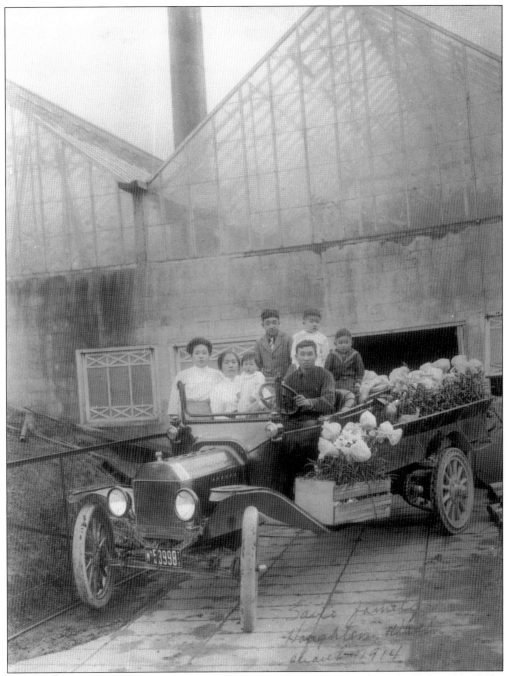

SAITO FAMILY, C. 1919. Ichiemon Saito, who arrived in 1916 to Houghton Greenhouses at Lake Washington Boulevard and Northeast 57th Street, grew flowers. In 1918, he operated the Boddy greenhouses, but then moved away in 1919. Note the large greenhouses, with a smokestack and two stories, and the truck loaded with wrapped-up Easter lilies. The truck is a chain drive conversion on a Model T sedan.

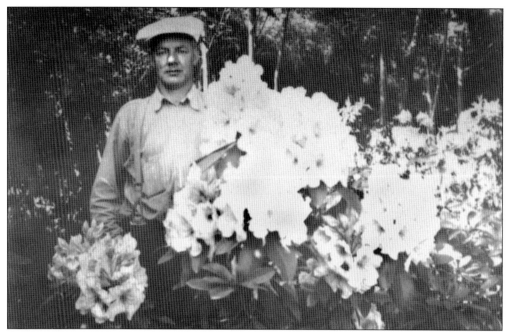

ANDRE OSTBO, LATE 1930S. In the late 1930s, Andre Ostbo bought several acres in Mercer Slough from the Winters and specialized in growing rhododendrons. Using some of the old greenhouses, Andre and his son Owen continued to operate his King of Shrubs nursery into the late 1970s. (Courtesy Ostbo family.)

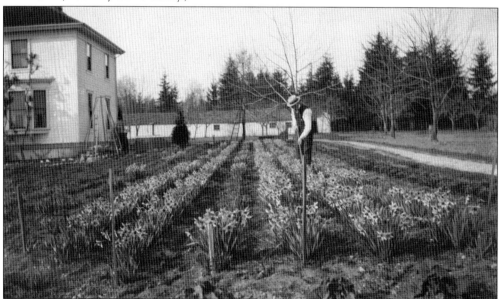

WILLIAM CRUSE, C. 1915. William Cruse was born in 1862 in Canada and moved to Bellevue in 1910; he cultivated daffodils and was active in Bellevue affairs. This photograph was taken in spring when the daffodils are in bloom, but there are no leaves on the trees. Here Cruse wears a hat and vest. His home was known as the Baker house, located on the site of the present-day Quality Food Market (QFC) across Northeast Eighth Street from Bellevue Square. He died in August 1928. (Phyllis Hill Fenwick collection.)

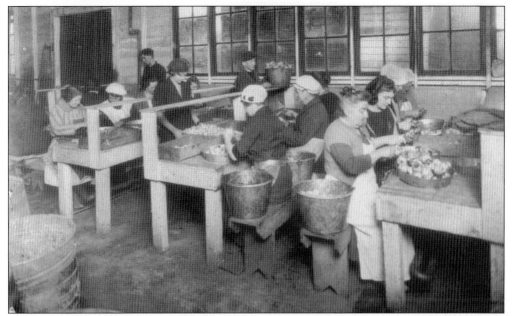

FISHER CANNERY, KIRKLAND, 1923. Pictured are Norman Blye's mother, Ione Blye (location not determined), and possibly his brother Don Blye, one of the men standing. They are peeling apples by hand, although at this time, mechanical peelers were readily available. The Blye family came to Bellevue in 1910, eventually renting Dr. Martin's house near 108th Avenue and Northeast Fourth Street. Ione (1882–1958) is laid to rest in the Kirkland Cemetery. (Norman Blye collection.)

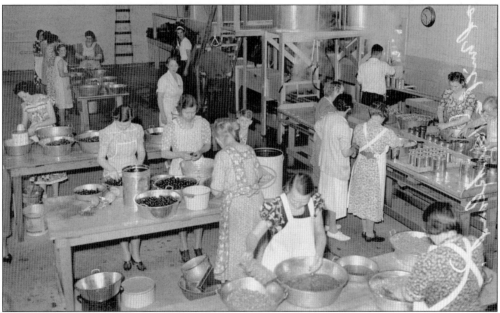

KIRKLAND CANNERY, JULY 13, 1939. The Kirkland Cannery was a Works Progress Administration (WPA) cooperative, a federal program to create jobs and provide income through public projects. Local citizens could bring in their garden crops (even chicken and fish) to be canned at no charge, if they set one third of their products aside as payment for use in state institutions. Everybody saved money and no cash was required. (Courtesy MOHAI.)

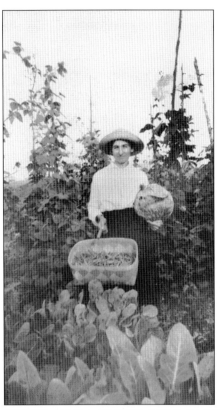

CECELIA WINTERS, 1917. Cecelia Winters appears to be pictured with beans, lettuce, and possibly cabbage. "I grew more vegetables than we could use. So, boys and I boarded their wagon once a week and sold them to summer people at Beaux Arts." In 1918, Cecelia said of their first greenhouse sweet peas (flowers), "We made $1,500 on these, so you can imagine why I worked 16 to 18 hours a day at one to one and a half cents per bunch." The Winters family switched to bulb farming in 1924, growing daffodils and iris. The Winters were members of the Eastside Grange, the local drainage district, and the Puget Sound Bulb Exchange. They eventually specialized in azaleas, before leaving in 1943. (Hennig collection.)

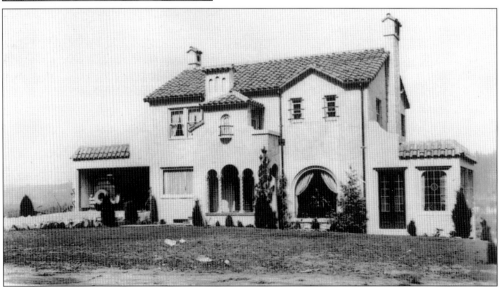

WINTERS HOUSE, 1935. Frederick and Cecelia Winters built this house in the late 1920s for about $32,000. They chose this Spanish Eclectic–style, influenced by the 1915 Panama-California Exposition in San Diego, as well as the architecture they enjoyed on a trip to Cuba. The City of Bellevue bought the house in 1988; it was rehabilitated and placed on the National Register of Historic Places. Today it houses Bellevue's Park Department, as well as research offices of the Eastside Heritage Center.

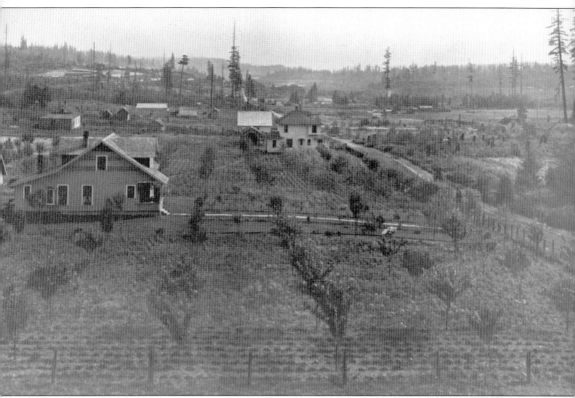

GODSEY FARM, EARLY 1900S. This image of Bellevue looks south on 116th Avenue, north of Northeast Eighth Street, the site of present-day Applegreen Center. The present-day Whole Foods Market would be in the photograph's center, and 116th Avenue leads from right. Homes in this area were built on small acreages, and orchard trees with smaller plants between the orchard rows are clearly visible. L. D. Godsey moved to this site in 1909 and opened L. D. Godsey and Sons Merchandise store. His sons James and Clell made deliveries by wagon. Nearby, a blacksmith shop and barbershop moved in, and the commercial center known as Midlakes was born.

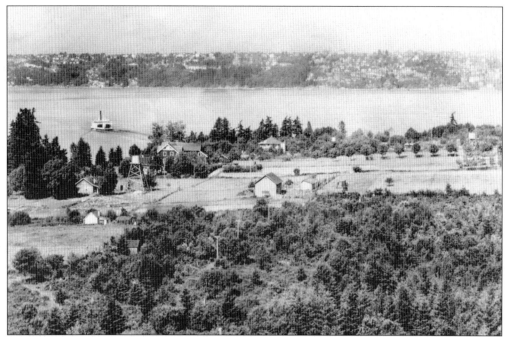

MEDINA FARMS WITH FERRY *LESCHI*, 1915. Small farms, woodlands, orchards, and pasture are dotted among three water towers. Towers created water pressure for domestic use, livestock, and firefighting. (Courtesy UW.)

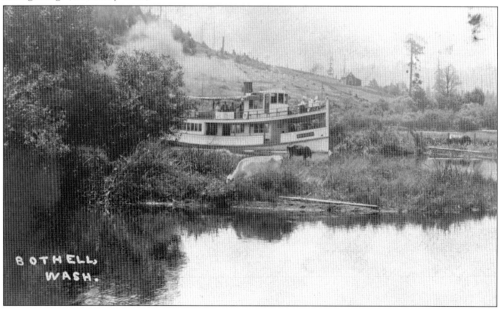

SQUAK SLOUGH, C. 1900. Cattle graze contentedly along the bucolic Squak (Sammamish) Slough connecting north Lake Washington with its smaller sister lake to the east. A farm is visible on the hillside, with hay shocks in neat rows. A fleet of steamers carried passengers and freight northeast to Bothell. A railroad parallel to the slough was built in the late 1890s, and construction of the ship canal in 1916 reduced water flow. Improved roads finally contributed to the demise of this form of transport.

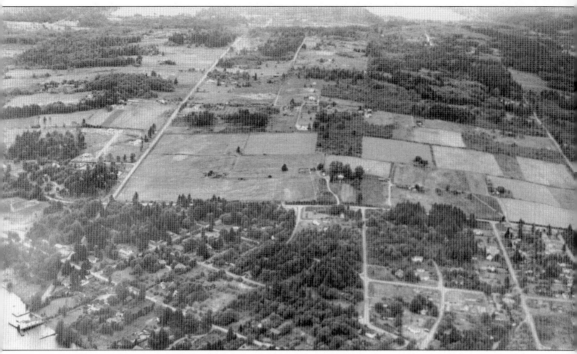

AERIAL VIEW, BELLEVUE, 1946. This view is from above Meydenbauer Bay, looking north. On the left is 92nd Avenue Northeast, and 100th Avenue Northeast is on the right.

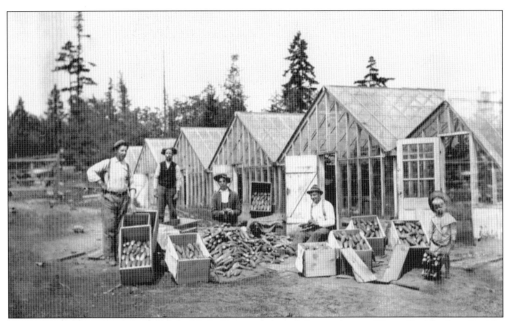

BODDY FARM GREENHOUSES, MID-1930S. Pictured, from left to right, are Harry Boddy, Sam Boddy, unidentified, unidentified, and Francis Boddy (son of Harry). The men are crating cucumbers for market. Six greenhouses are visible. By 1942, there were seven greenhouse operations in the Bellevue area. Francis Boddy (1835–1904) is laid to rest in the Sunset Hills Memorial Park, Bellevue. Samuel Boddy (died 1949) is laid to rest in the Kirkland Cemetery.

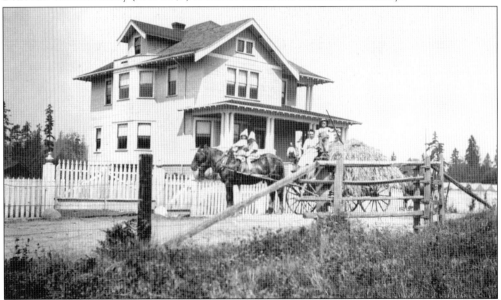

BODDY FARM, "BIG HOUSE," 1928. This horse-drawn buggy carries a hay load in front of substantial three-story house. It's not known why the hay is on the buggy rather than a wagon. The unusual gate in foreground uses sliding rails rather than gate hinges. With a substantial barn, numerous greenhouses, and a three-story home, the Boddy family gave every appearance of being prosperous farmers; precursors to the prosperous Seattle business folks who would ultimately make their homes on Hunt's Point.

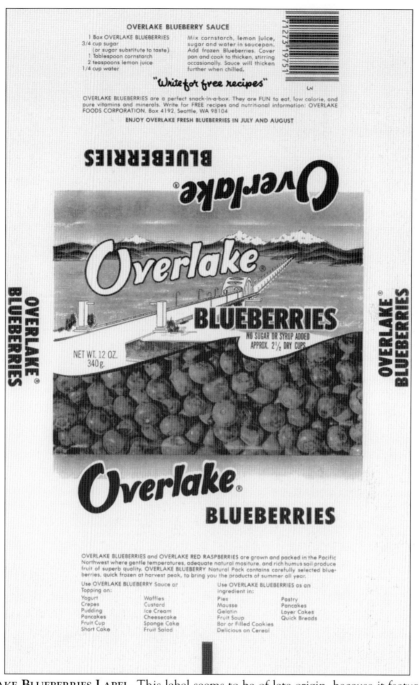

OVERLAKE BLUEBERRIES LABEL. This label seems to be of late origin, because it features a zip code and the first floating bridge. During and after World War II, Japanese farmers were absent from Bellevue, and truck farming abruptly declined. Some of the acreage was converted to blueberries. Louis Weinzirl started his blueberry farm, followed in 1947 by the Overlake Blueberry Farm, operated by Lee Dennison and Ernest Van Tine. It took 10 years to propagate the bushes and let them reach maturity, but then the farm became very productive, yielding an average 100 tons annually.

SYDNOR'S UPLAND SOIL BLUEBERRIES. "They're sweeter." Sydnor's was located at the latter-day site of the John Danz Theater and the Barnes and Noble bookstore. Since this was not an acidic wetlands site, the soil was considered "upland" and therefore the claim of sweeter berries.

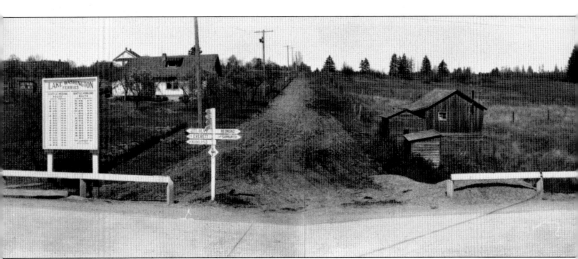

BELLEVUE WAY AT MAIN STREET, LOOKING NORTH, 1928. Here Bellevue Way (then called 104th Avenue) is a gravel road; visible are houses, pastures, and orchards. Main Street (in the foreground) is paved, with directional signs to the ferry, Redmond, etc. The ferry route is along Lake Washington Boulevard to the dock at Medina.

Five

LAKESIDE COMMERCE

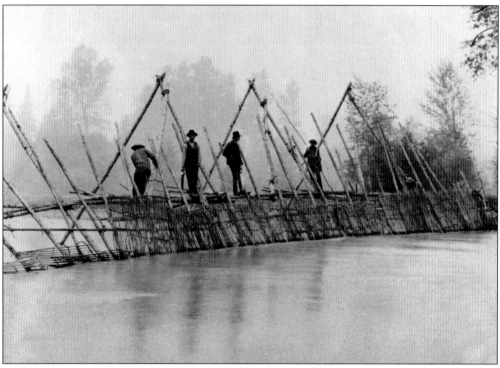

FISH WEIR, C. 1893. Native Americans used traps like this for thousands of years to catch salmon at spawning streams entering the lake. They set the poles across the stream, directing the fish into a type of underwater basket to be speared or caught. The flesh was then filleted and smoked over fire or dried in the sun, providing a commodity for trade and a year-round source of food. The men pictured here probably traded fish for the wool clothing they are wearing. As settlers arrived and stayed, commerce took on a more industrial nature. Logging required oxen, horses, and steam power. Coal mining required the rail. Shipbuilding and even whaling fleets flourished on the lake's eastern shore. Brick making, a compass factory, and a railcar factory all operate today, while Peter Kirk's plans for steel works to rival Pittsburgh fell through. Lake Washington supported all of these commercial endeavors and more, as mankind took to the skies, testing jumbo jets high above the wide expanse of water. (Courtesy UW.)

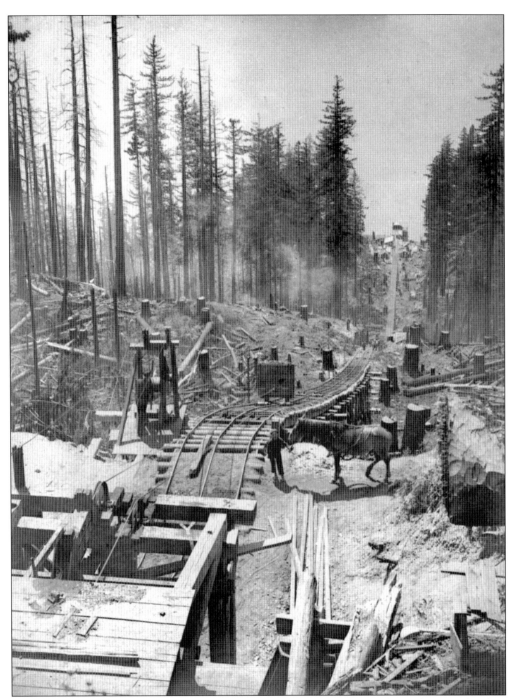

COAL TRAM. This tramway was built in the early 1800s to get coal cars down the steep bank to the lake for the trip to Seattle. The horse had just pulled the car over a mile on flat ground from the Newcastle mines at Coal Creek. The location was near today's Pleasure Point, which at the time was known as Hazelwood, Newport, or Benson's Landing. In the early days, shallow-draft steamers took bags of coal down the Black River at the south end of the lake, out the Duwamish River to Seattle.

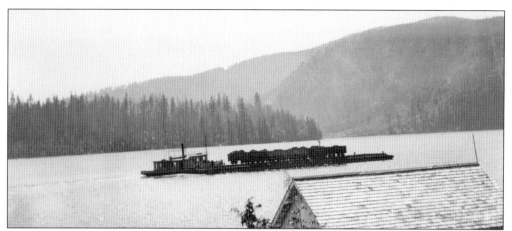

COAL BARGE, 1898. After 1872, coal cars were wheeled directly onto a barge fitted with rails, which was pushed or towed across the lake to Montlake, where another series of trams and barges took the cars across Lake Union and through Seattle to the docks. By then, the coal had been handled 11 different times. This coal barge is on Lake Whatcom near Bellingham, but the Lake Washington operation would have been nearly identical. The first large industry in the Seattle area was coal mining at Newcastle and at Coal Creek beginning in 1865. King County coal production rose to a record high of nearly 1.5 million tons in 1907. By 1943, it had decreased to about 500,000 tons annually. The total recorded King County output is 47 million tons, topped in Washington State only by Kittitas County. Coal was shipped to San Francisco and was also used by railroads, steamships, and for local heating and industry. (Courtesy UW.)

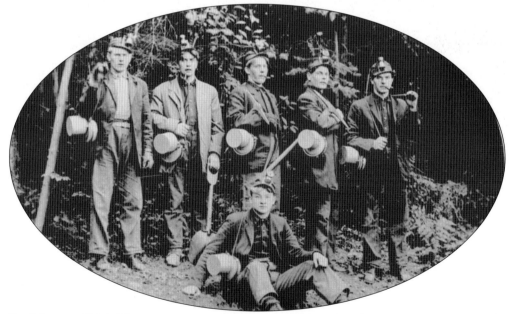

SIX MINERS, 1889. These miners carry lunch pails and have headlamps. At the town saloon, 5¢ would get your pail filled with beer after work. Eastside coal miners typically came from coal mining families in Europe. Ethnic groups strongly represented here were English, Welsh, Finnish, and Italian. Also working the mines were Poles, Swedes, Croats, Scots, Irish, Greeks, and African Americans from Missouri. Many Chinese laborers settled along a Lake Boren stream that is known today as "China Creek."

BRIQUET PLANT, EARLY 1900S. The Pacific Coast Coal Company was the largest and most stable of all the Eastside mining companies. It is still in business as Palmer Coking and Coal today. In 1913, the company built a briquet plant on the shores of Lake Washington to compress small coal particles into marketable "bricks of quality coal." The plant produced 40 to 100 tons annually and had a conveyor belt five feet wide and over 300 feet long. (Richard McDonald collection.)

RENTON CLAY PLANT. Clay was found near the coal beds at Renton, Taylor, and Van Asselt. Small operations in each area merged to form the Denny-Renton Clay and Coal Company in 1905, becoming the largest producer of pavers in the world, making 58 million bricks in 1917. Many Seattle and University of Washington buildings are made with brick from Eastside clay. (Courtesy Renton Historical Society.)

LOGGING CREW, 1925. Two men are lying in the notch of the 10-foot-diameter tree and other men are standing on the springboards, used to get above the underbrush and the flared base of the tree. The men would then make the undercut notch with axes and finish with a backcut made by the cross-cut saw. Loggers usually worked in pairs, often taking all day to fell one giant tree. Lake Washington was once fully encircled by 700-year-old trees this big.

OX TEAM, 1880s. Oxen have great pulling power, and many of those that crossed the plains on the Oregon Trail were brought north for logging. Others came by ship from California or even Australia. However, they were bulky and sometimes stubborn; the driver was noted for frequent use of profanity as well as a bull whip. He was called "the bull of the woods" or simply, a "bull puncher."

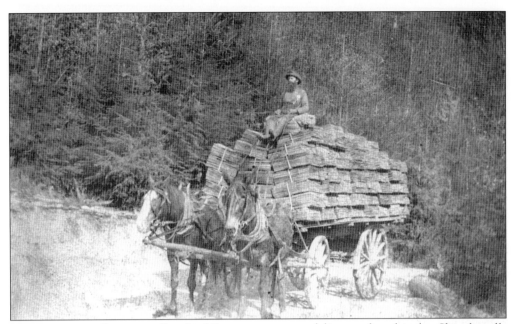

WAGONLOAD OF SHINGLES. Gottfried Everson sets out to deliver roofing shingles. Shingle mills had power-splitting machines, and a workman who did not lose his fingers to the unguarded blades could produce as many as 1,000 shingles in a 10-hour day. These men were known as "shingle weavers" for stacking the wedge-shaped shingles in alternating directions to make a compact bundle that the roofer could carry up a ladder on his shoulder.

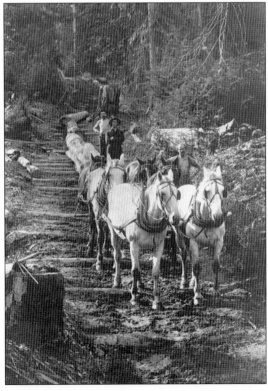

HORSE TEAM ON SKID ROAD. Horse teams replaced oxen because the horses were more agile and could work in rougher country. The oxen also had a tough time with the wet climate and deep mud, which for them resulted in diseases and hoof-rot. Note that smaller logs have been placed across the trail here to create a "skid road." Sometimes a man or boy would run on ahead and grease the logs with dog-fish oil or bear grease. They had to be agile too, and they became known as "grease monkeys."

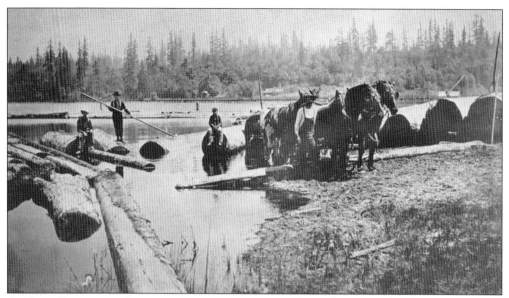

RAFTING LOGS NEAR JUANITA, C. 1890. Big trees were usually cut into 20-foot lengths, then pulled by horse teams to a millpond, or in this case, the lake. The man standing uses a pike pole to maneuver the big wood. "Ponding" allowed for easy storage and sorting of the logs, washed the dirt off, and kept the wood soft, which was easier on the saw teeth. This photograph appears to be near the Dore Forbes Mill, which operated from 1878 to 1894.

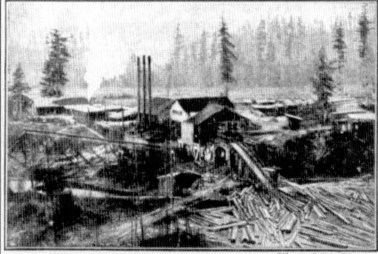

ADVERTISEMENT FOR WILBURTON LUMBER MILL, C. 1905. This mill operated at the head of Mercer Slough in Bellevue from 1901 to 1919. It had a daily capacity of 75,000 board feet of lumber and 170,000 shingles. A boom town of 400 grew up around it, making Wilburton larger than Bellevue at that time. The Northern Pacific Railroad ran right next to it, connecting to Renton in the south and Woodinville to the north.

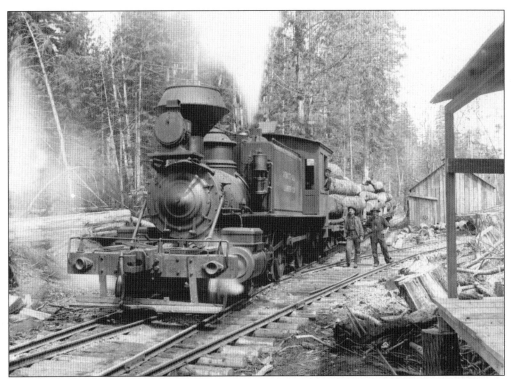

HEWITT AND LEA LOCOMOTIVE, C. 1905. Logging railroads made possible the second phase of Eastside logging. In 1901, Wilbur and England built a sawmill near today's 116th Avenue and Main Street in Bellevue, followed in 1903 by Northern Pacific's construction of the Wilburton train trestle. In 1905, the Hewitt and Lea Lumber Company took over mill operations and used this locomotive on 10 miles of its own track "to log everything between Kirkland and Kennydale."

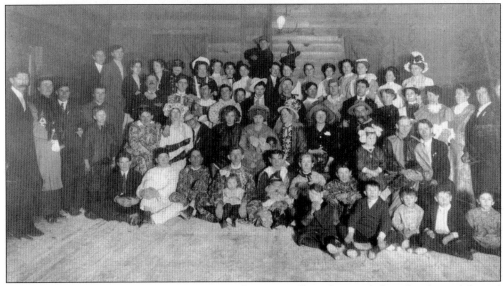

NEW YEAR'S EVE PARTY, 1904. In 1904, Wilburton Mill workers and their families celebrated at this New Year's Eve Party. Some of the partygoers are wearing Baby New Year and Uncle Sam costumes.

PACCAR TANK ASSEMBLY LINE, 1943. During World War II, PACCAR manufactured products needed by the military. William Piggott began the Seattle Car Company in 1905, making railcars to transport logs. By 1917, it had become Pacific Car and Foundry Company (PACCAR), with an order for 2,000 boxcars. During World War I, it also produced over 900 Sherman tanks. Today it is known for Kenworth and Peterbuilt trucks. (Courtesy MOHAI.)

MATZEN WOOLEN MILL, 1920. The overhead line shaft powered all of the different machines via leather drive belts. The quality of Lake Washington water (in 1890) was said to be a key factor in the scouring and coloring of the wool, making it possible to manufacture "two grades coarser than any wool that can be made in the east." For years, this mill was Kirkland's largest business and the state's only woolen mill. Products kept loggers, fishermen, and even "doughboy" soldiers warm. (Courtesy Washington State Historical Society.)

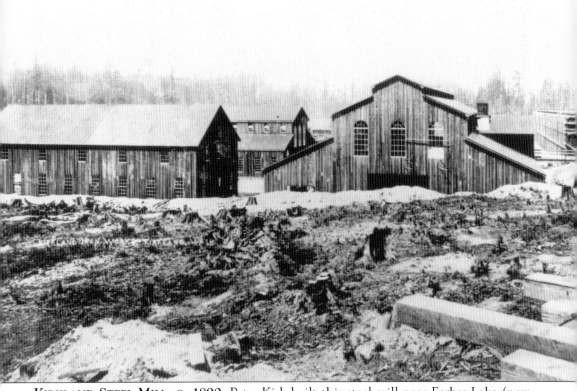

KIRKLAND STEEL MILL, C. 1890. Peter Kirk built this steel mill near Forbes Lake (now Lake Kirkland, just east of I-405). His plan to combine iron ore from Snoqualmie Pass with Newcastle or Wilkenson coal was thwarted by the economic collapse of 1893, but his office building, his town plat, and his name live on today in the city of Kirkland at the edge of Lake Washington.

ADVERTISEMENT FOR "DIRIGO" COMPASS, 1911. The Dirigo was a ship's compass built by Eugene M. Sherman, who founded Bellevue's first business, employing 5 to 18 people. From 1911 to 1944, he supplied navigation instruments to northwest fishermen, navy vessels, and ferryboats. The thank you card has a French postmark and is from a happy customer who had just used a new Sherman compass to cross the Atlantic Ocean.

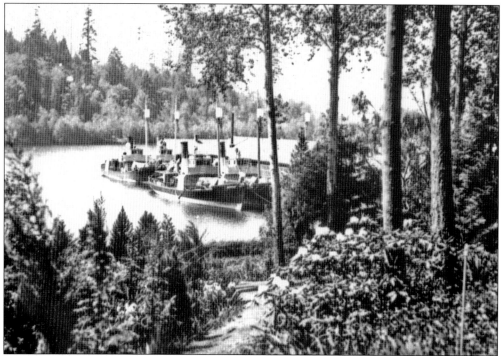

WHALING FLEET IN MEYDENBAUER BAY, 1930s. The American Pacific Whaling Company wintered in Bellevue's Meydenbauer Bay during the 1920s and 1930s. Owner William Schupp moved his headquarters here so his eight vessels could have a freshwater anchorage and a nearby shipyard for repairs. Freshwater kills the saltwater barnacles and seaweeds that otherwise harm and slow down the boats. The whales were butchered and sold in Alaska; none of the animals were brought into Bellevue. (William Lagen collection.)

TUGBOAT. Barbee Mill at the mouth of May Creek was the last lumber mill on Lake Washington. It closed in 2005, but many residents can recall tugboats pulling rafts of logs or pilings up and down the lake. In logging's heyday, from 1890 to 1920, nearly every bay on the lake was full of logs and had its own sawmill or shake operation. "It seemed at times like you could walk on the logs all the way across the lake." (Courtesy *The Seattle Times*.)

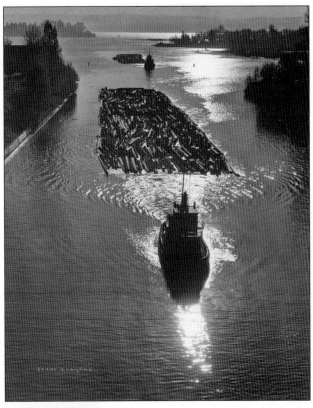

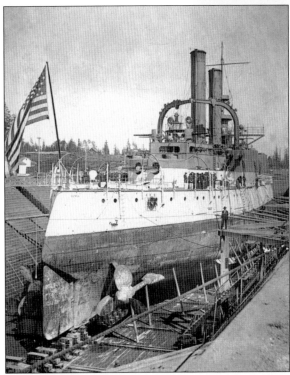

GUNBOAT *IOWA*, WORLD WAR I ERA. The Lake Washington Shipyard began when the small steam scow *Squak* was built at that location in 1884. Capt. John Anderson bought the Houghton yard in 1907 and proceeded to build a whole fleet of passenger steamers. He capitalized on the Alaska-Yukon-Pacific tourist trade by offering 25-mile tours of the lake for 25¢.

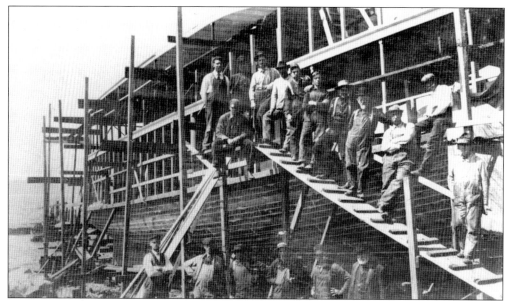

STEAMER ATLANTA, C. 1907. The Houghton, or Lake Washington Shipyard, was little more than a flat spot on the beach when Capt. John Anderson bought it in 1907. The Curtis brothers had built the *Elfin* and the *Edith E.* there, but when Bartsch and Tompkins sold the yard to Anderson, the windlass was still powered by a mule! Anderson quickly employed a steady crew of craftsmen, shown here with their first project, the passenger steamer *Atlanta*.

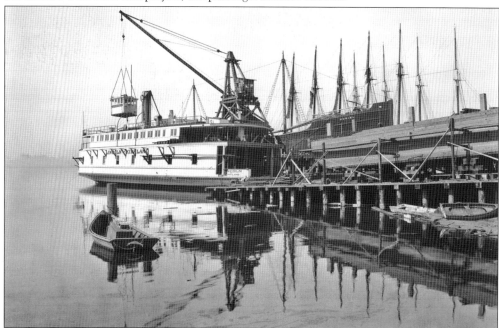

FERRYBOAT LINCOLN, C. 1920. To ensure accurate compass readings, wheelhouses like this one being lifted onto the *Lincoln* were usually made of wood, or sometimes even non-magnetic copper. This was a time of transition from sail to steam; note the masts of sailing ships behind the warehouse. The shipyard built a number of local ferryboats that were used on Puget Sound as well as Lake Washington. (Courtesy MOHAI.)

SHIPYARD NEWSLETTER, FEBRUARY 23, 1945. The Lake Washington Shipyard really expanded during both world wars. World War I brought orders for ocean-going vessels and four 3,500-ton freighters for the French government. World War II brought rivets, welding, and steel hulls. Navy records show that the yard had contracts to build 4 submarine tenders, 24 seaplane tenders, and 3 torpedo boat mother ships. By the end of the war, over 447 ships of all types had been repaired here.

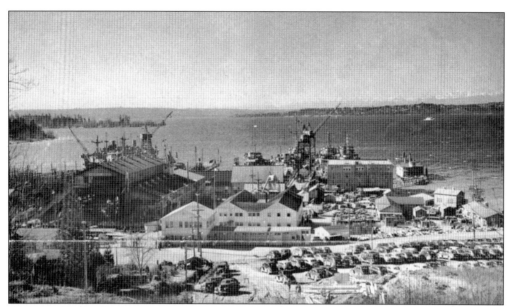

LAKE WASHINGTON SHIPYARD, 1945. This aerial view shows the Lake Washington Shipyard at its peak of activity during World War II. There were four cranes in use, many new large buildings, and boats of all sizes tied to docks and even pilings in Yarrow Bay. At this time, over 6,000 workers were employed, and there were 25 ferry runs to Seattle everyday.

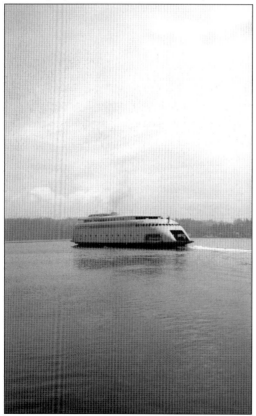

FERRY KALAKALA, C. 1935. The Lake Washington Shipyard produced the ferry *Kalakala* (flying bird), the world's first completely streamlined vessel. Boeing engineers helped develop the aerodynamic design. It took electric welding of 800 tons of steel plates and shapes to make the boat a reality. It was designed to carry 1,000 passengers and 110 automobiles, and it made eight round trips a day for over 30 years on the Seattle–Bremerton run.

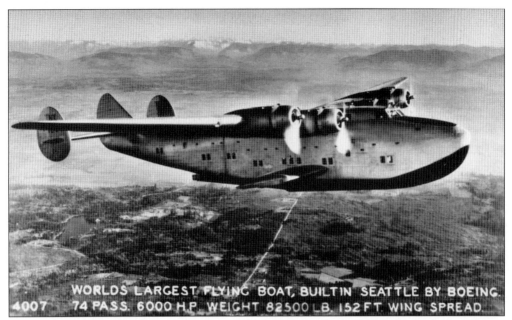

BOEING 314 "FLYING BOAT," C. 1939. From 1937 to 1941, the *Ocean Queens* flew both the Atlantic and the Pacific for Pan American Airways. At that time, the 314 was the largest plane flying, and it did it all in luxury style. For a time, one clipper even flew a regular route to Ketchikan and Juneau in Alaska from Matthew's Beach on Lake Washington. (Courtesy MOHAI.)

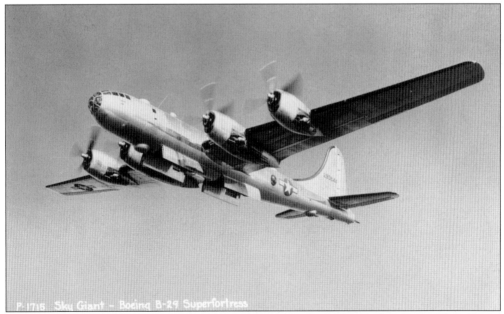

BOEING B-29, C. 1944. The Boeing plant at the south end of Lake Washington produced 1,119 B-29 bombers by the end of World War II. Many credit this long-range aircraft as being the key factor in finally ending the war. Locally it meant employment and a steady paycheck for over 40,000 workers. (Courtesy MOHAI.)

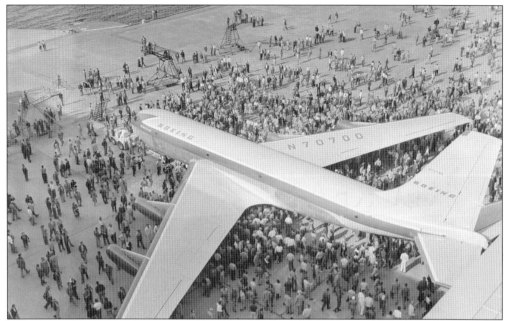

ROLLOUT OF THE DASH 80, 1954. The Dash 80 was the Boeing 707 jet transport/tanker prototype, also known as the "$16 million gamble" because the company spent that much on research and development despite having no orders for the plane. At the 1955 Seafair hydroplane race, test pilot Tex Johnston made it world famous by doing aileron rolls that put it upside down over the racecourse twice. (Courtesy MOHAI.)

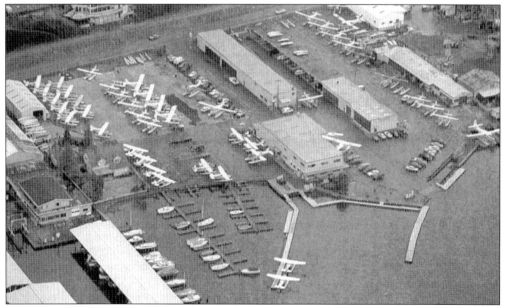

KENMORE AIR HARBOR, 1993. This seaplane base at Lake Washington's north end is the largest in the nation. It is home to over 120 aircraft and has supplied charter service to remote parts of Washington State, Canada, and Alaska since 1946. One contract with the University of Washington even called for float-plane landings and takeoffs from Olympic Mountain glaciers in order to take ice-core samples. (Courtesy *Journal American* newspaper.)

Six
RECREATION ON AND BY THE LAKE

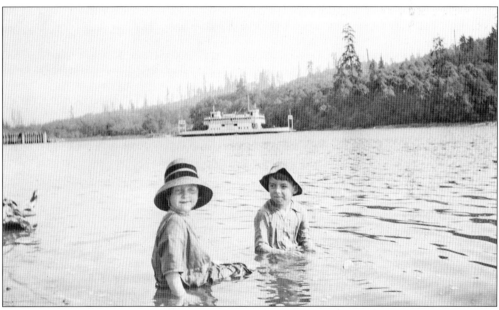

CHILDREN IN LAKE WASHINGTON, C. 1920. Phyllis Hill and her friend Ted McCreary soak up the waters of Meydenbauer Bay in this popular EHC photograph. The ferry *Leschi* is visible in the background. Since Metro's successful lake cleanup began in 1958, the water has remained clear and clean. Well-kept public and private beaches with wooden docks dot the lake's eastern shoreline today. Pleasure boating is popular year-round, reaching its annual zenith in August during SeaFair, when bridge traffic is cleared for the thrilling Blue Angels air show over the lake. Out on the lake, on clear days, one can see Mount Baker to the north and Mount Rainier to the south. No Eastside summer is complete without a sunset-washed evening in one of the area's fine restaurants or walking along the water's edge. Lake Washington is a local jewel that, while physically separating Seattle from the Eastside communities, unites these metropolitan areas recreationally on a unique and treasured watery playground. (Phyllis Hill Fenwick collection.)

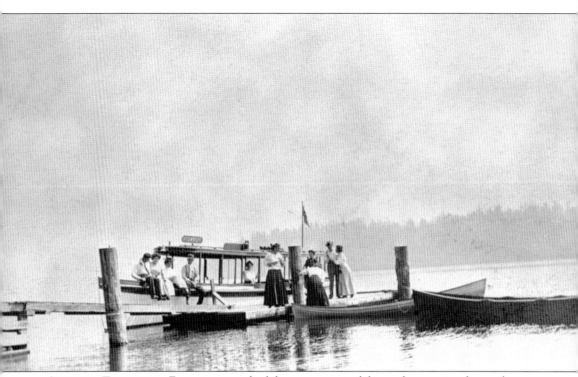

STEAMER THORNIETA. Excursions on the lake were a typical form of recreation for residents on the Eastside. This photograph shows the ferry *Thornieta*, about which little is known.

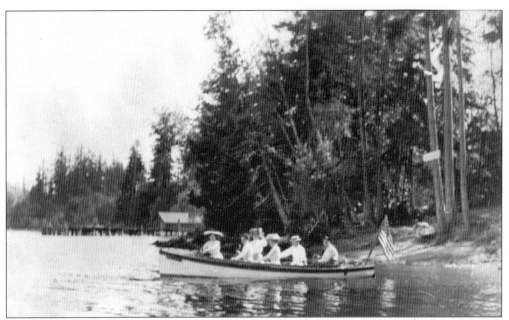

COZY COVE, C. 1910. Members of the Adolph Meydenbauer family enjoy a boat ride at Cozy Cove on Hunt's Point. Meydenbauer purchased a lot and erected a vacation cottage there after he sold all of his acreage on Meydenbauer Bay. He tried to buy some of that acreage back, but decided that $75 per acre was too high. (Meydenbauer collection.)

WADING IN MEYDENBAUER BAY, C. 1912. Lake Washington has always been a popular swimming lake, made even more accessible to pioneer families after the Lake Washington Ship Canal construction lowered the lake in 1916, resulting in greater beach access. The woman on the right is Millicent Sterling. (Phyllis Hill Fenwick collection.)

COUSINS AT MEYDENBAUER BAY, C. 1919. The Hill cousins, pictured, from left to right, are Ryland, Phyllis, Glenette, Gretchen, and Allan. Phyllis Hill Fenwick was born in Seattle on February 4, 1913, and lived in Bellevue from infancy until her death on April 26, 2004. (Phyllis Hill Fenwick collection.)

WILDWOOD PAVILION, EARLY 1900S. The pavilion was a popular destination for groups visiting from Seattle via ferry, and it fell on hard times when regular ferry service to Meydenbauer ended in 1920. Entertainment included orchestras, boxing matches, and even a roller-skating rink. The Bellevue Community Club held its first annual picnic here in August 1923. The upper part of the site is now Bellevue's Wildwood Park on 101st Avenue Southeast. (Courtesy UW.)

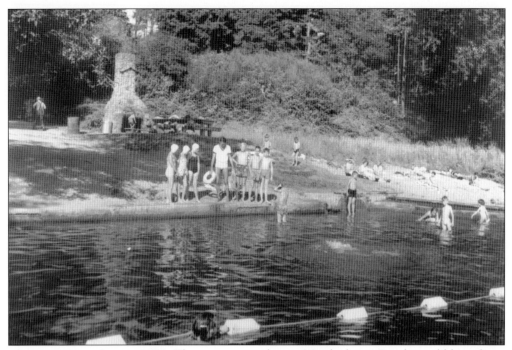

WATER SAFETY CLASS, 1955. This swimming class at Meydenbauer Beach would have been typical of the kind taught by county park water-safety instructors, beginning in 1949. The program taught adults and children how to swim.

CITY OF BELLEVUE RECREATION, 1968. The City of Bellevue ran a comprehensive recreation program that included swimming, diving, sailing, and lifesaving classes at the city's beaches. In the late 1940s, the Bellevue Recreation Council worked closely with King County Parks and Recreation to provide summer and year-round programs. They even offered water skiing. Water safety education was always a primary goal. (Hennig collection.)

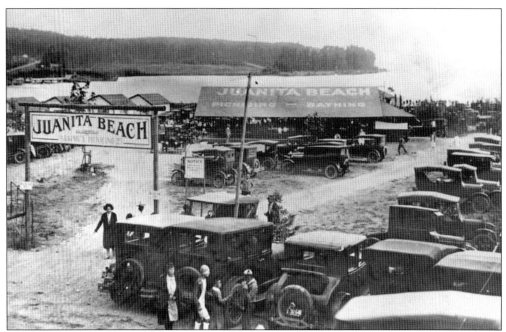

JUANITA BEACH, C. 1925. With the completion of roads to the Eastside, Juanita Beach, north of Kirkland, became a popular destination for daytrips from Seattle. At the height of its popularity, the resort had a dock, cabins, and a 5,000-square-foot dance pavilion. Juanita Beach Park is still a popular place to swim and picnic, but no longer costs 25¢ to enter.

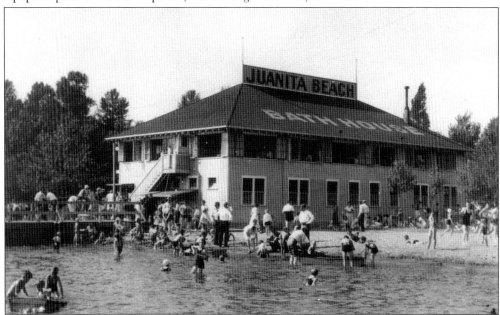

JUANITA BEACH, C. 1935. This larger bathhouse was added to Juanita Beach resort in 1928. Juanita Beach was a family beach, as opposed to Atlanta Park in Houghton and Wildwood Pavilion in Bellevue that had occasional rowdy weekends that might have included Prohibition alcohol. Swimmers rented swimsuits and beach towels, neither of which was considered necessary to own back then.

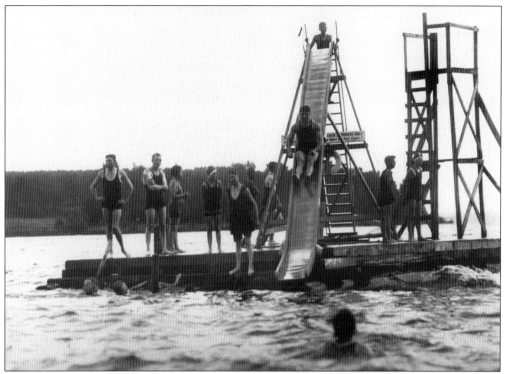

SWIM RAFT, 1925. Many swimming areas at local beaches on the lake featured high dives and large water slides, like this one at Juanita Beach. These bathers model the swimming fashions of 1925. The men's suits were often made of wool.

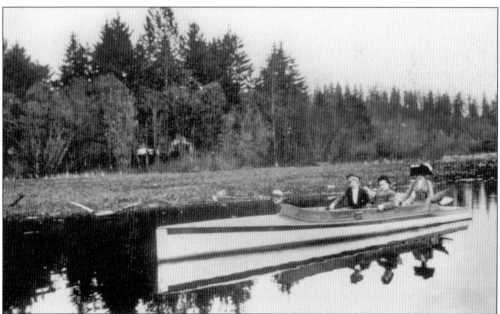

PLEASURE BOATING, C. 1910. An elegant motor launch explores the waters of the Mercer Slough. The high water in the slough reveals that this photograph was taken before the lowering of the lake in 1917. (Sharpe collection.)

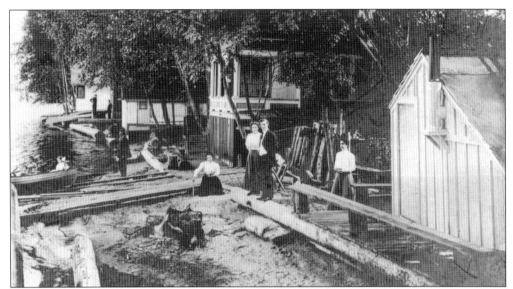

CABINS ON LAKE WASHINGTON, 1908. Christian Miller built these cabins on the Lake Washington shores. In the early days, it was common for Seattleites to build cabins around the shoreline of Lake Washington. (Courtesy Rainier Valley Historical Society, Duncan collection.)

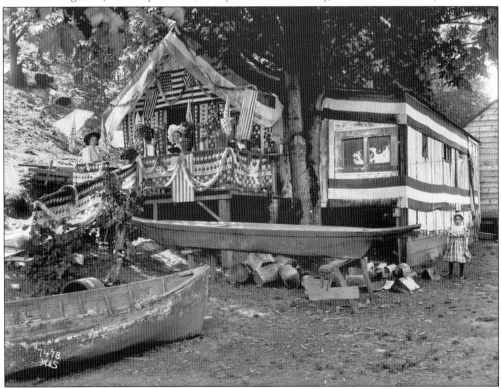

LAKESHORE CABIN, 1912. During the summer, many Seattle residents enjoyed camping on the shore of Lake Washington or in cabins along the lake. This trio poses with their cabin decorated for the Fourth of July. A rowboat is pulled up on the shore and a Salish-style dugout canoe sits on sawhorses. (Courtesy MOHAI.)

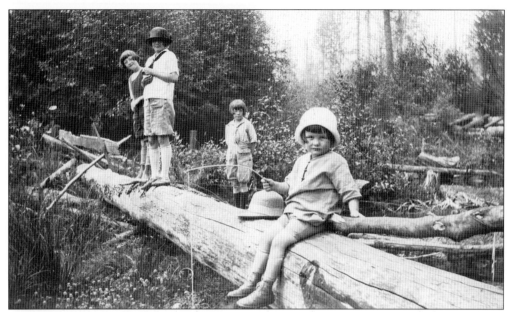

FISHING ON JUANITA CREEK, 1923. The Hill cousins, pictured, from left to right, are Phyllis, Glenette, Gretchen, and Gene. They are trying their luck with sticks, string, and hooks. (Phyllis Hill Fenwick collection.)

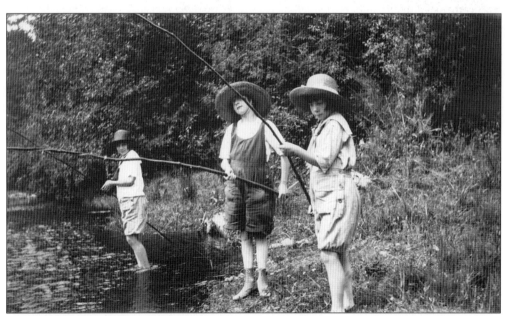

FISHING, 1923. Here the cousins try another fishing hole. Pictured, from left to right, are Glenette, Phyllis, and Gretchen Hill. Phyllis would have been about 10 years old in this photograph. (Phyllis Hill Fenwick collection.)

BELLEVUE MARINA, 1950s. With the demise of the Meydenbauer whaling fleet headquarters, pleasure boats owned by the burgeoning population of the Eastside moved in. The City of Bellevue purchased this marina in 1998 from Bill Lagen, grandson of William Schupp, owner of the whaling fleet that wintered here in the 1920s and 1930s. It became a link in the chain of city-owned properties to eventually form a waterfront park along Meydenbauer Bay. (William Lagen collection.)

SAILING ON THE LAKE, LATE 1930s. Eugene Sherman (center, with hat) takes family and friends out sailing on Lake Washington. Sherman owned the Compass Factory, producer of the Dirigo compasses that shipped worldwide. He built this ketch on his company's site in Bellevue. He was also a skilled violin maker. Smaller sailboats, like the one in the background, were plentiful on the lake. (Kimsey/Burnell collection.)

MEYDENBAUER YACHT CLUB, 1990S. The yacht club was founded just after World War II. The clubhouse was built at the head of Meydenbauer Bay at 9927 Meydenbauer Way SE, on the site of the defunct Wildwood Pavilion. It is one of the most imposing buildings that date from pre-World War II Bellevue.

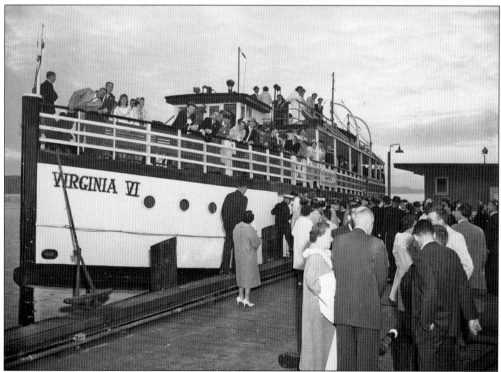

GRADUATION EXCURSION, 1955. A Lake Washington High School graduation party gets ready for a lake excursion aboard the *Virginia VI*. Research indicates this may be a restored original steamboat, the *Arcadia*.

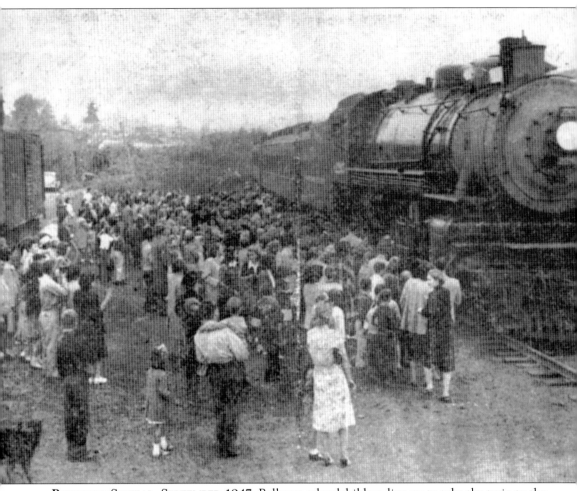

PUYALLUP SPECIAL, SEPTEMBER 1947. Bellevue schoolchildren line up to take the train to the Western Washington Fair. They loved the plush "two-way" seats and riding across the Wilburton trestle. Decades earlier, the train provided transportation from Bellevue to Seattle through Renton, a one-hour, one-way journey that cost 80¢ round trip.

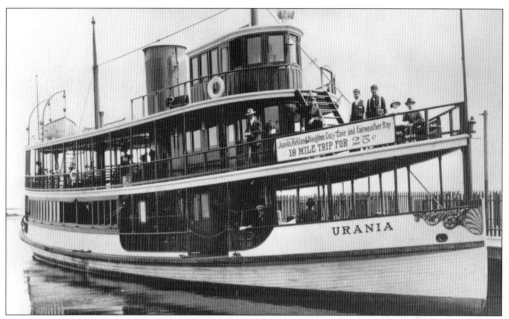

EXCURSION STEAMER URANIA, 1908. The *Urania*, along with the *Atlanta* and the *Triton*, were built at the Anderson Shipyard in Houghton in anticipation of growing excursion traffic from the Alaska-Yukon Exposition of 1909. Successors to these vessels still take excursions to the same destinations on Lake Washington, though the fare has certainly increased. (Tillaman collection.)

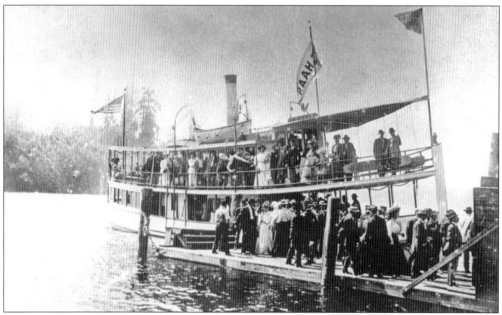

STEAMER *LT HAAS*, C. 1900. The 67-foot steamer *LT Haas* began passenger service on Lake Washington in 1898 and later provided excursions to Wildwood Park on Meydenbauer Bay. Its dynamo was carried up to the pavilion to provide light for the dance floor. It was owned by Alpheus F. Haas, a Seattle city council member, who also owned 15 acres of Bellevue farmland. Its burned hull lies at the bottom of Lake Washington off Houghton. (Courtesy UW.)

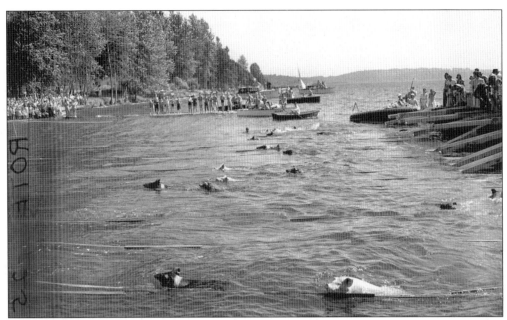

PIG RACES, 1946. Pigs may not be able to fly, but they can swim. Over 6,000 gathered to view the pig swimming races, a star feature of Kirkland's 1946 Water Carnival. The race garnered national press, to the delight of city promoters hoping to lure new residents into this new bedroom community. Bob Ferris, of KJR, handled the play-by-play of the race for ABC radio. The summer carnival went on to become an annual event for many years. (Courtesy MOHAI.)

WINNING PIG, 1946. The winning pig is clearly getting more attention than the bathing beauties. The winner of the race was the triumphant Rose of Normandie. She won the race in 45 seconds, which was pointed out to be a world record, considering that this was the first aquatic hog race in history. Second place was awarded to Wafford, and Omak came in third. However, the big winner was the City of Kirkland, which basked in the media spotlight. (Courtesy MOHAI.)

ICE SKATING ON LAKE BELLEVUE, EARLY 1930S. Lake Bellevue, once called Lake Sturtevant, is a small body of water northeast of Bellevue's downtown area. Up to the early 1950s, parts of area lakes, including Lake Washington, froze in winter. These children are enjoying winter on the ice.

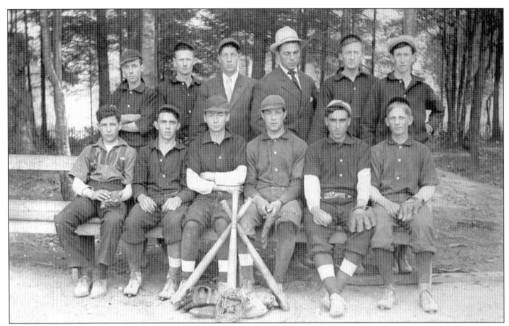

WILBURTON MILL BASEBALL TEAM, 1908. This group, likely composed of loggers from the Wilburton Mill, probably played at the baseball diamond upland from the Wildwood Pavilion on Meydenbauer Bay. Baseball was a popular recreational pastime.

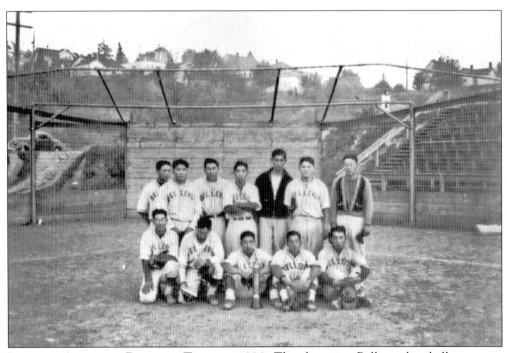

JAPANESE AMERICAN BASEBALL TEAM, C. 1930. The champion Bellevue baseball team was at the annual three-day tournament for the Puget Sound Area Japanese teams held in Seattle. Coach Tok Hirotaka is in the second row, far right. (Tok Hirotaka collection.)

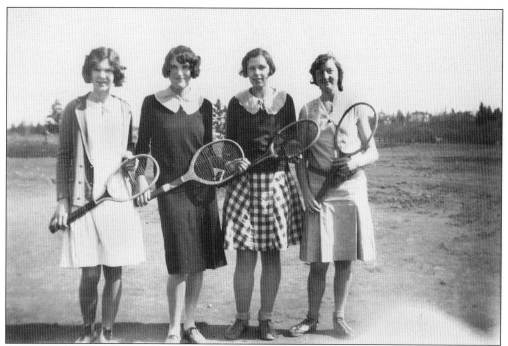

TENNIS PLAYERS, 1928. These Bellevue High School girls, from left to right, are Florence Hennig, Dorothy Groves, Marguerite Schafer, and Phyllis Hill. (Phyllis Hill Fenwick collection.)

CHILDREN AT THE PARK, 1942. Cousins Barbara (Eminson) Stull and Diana (Schafer) Ford (first row, left and right) enjoy a sunny summer day at Meydenbauer Bay in Bellevue with a party of friends. (Diana Schafer Ford collection.)

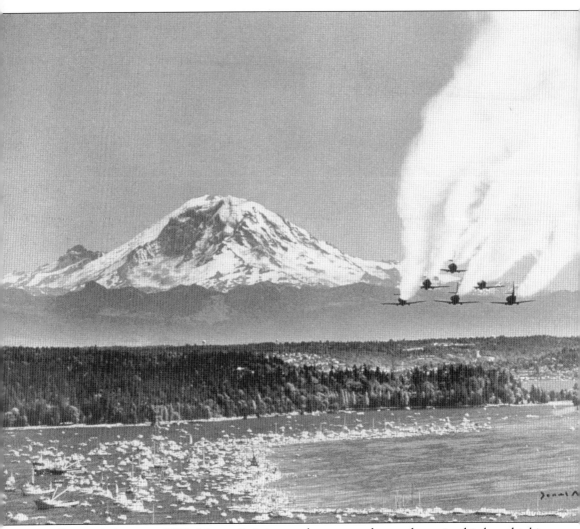

SEAFAIR, AUGUST 1978. Mount Rainier can be seen to the southeast in this breathtaking photograph of the highlight of the Seafair festival. Traffic on the floating bridges is cleared during the annual performance by the Blue Angels. In 2005, Seafair drew hundreds of thousands of spectators who luxuriated in the typically clear weather showing off Lake Washington at its best. (Photograph by Joseph Scaylea; courtesy MOHAI.)